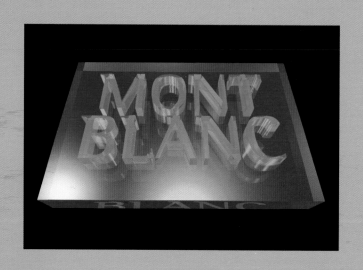

QUICK AND EASY 3D EFFECTS

SIMON DANAHER

Focal Press

OXFORD AMSTERDAM BOSTON LONDON NEW YORK PARIS
SAN DIEGO SAN FRANCISCO SINGAPORE SYDNEY TOKYO

Focal Press
An imprint of Elsevier Science
Linacre House, Jordan Hill, Oxford OX2 8DP
First published 2003

British Library Cataloguing in Publication Data
A catalogue record for this book is available from the British Library

ISBN 0 240 51922 1

For information on all Focal Press publications visit our website at
www.focalpress.com

This book was conceived, designed and produced by:
The Ilex Press Limited, Cambridge, England

Art Director: *Alastair Campbell*
Editorial Director: *Steve Luck*
Design Manager: *Tony Seddon*
Designer: *Kevin Knight*
Project Editor: *Stuart Andrews*
Development Art Director: *Graham Davis*

Typesetting and repro by Hong Kong Graphics & Printing Ltd, China
Printed and bound by L-Rex Printing Company Ltd, China

For more information on quick and easy 3D effects
visit: **www.3D-wizardry.com**

CONTENTS

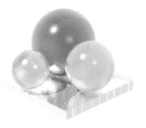

WHAT IS 3D?

If there's one thing this book will teach you, it's that 3D graphics don't have to be difficult. While high-end 3D tools take time to learn and understand, particularly if you come from a 2D design background, there are easier ways of giving your work a third dimension. In fact, some amazing 3D graphics can be created using familiar 2D tools such as Adobe Photoshop or Illustrator – tools that you are probably more comfortable using.

The hologram is the only true 3D form of representation, but we're still some way from lifelike, full-colour, high-resolution images.

Using 2D tools to create 3D graphics is really nothing new. After all, painters have been doing it for centuries. Take a trip to the Convent of Santa Maria delle Grazie in Milan for a look at Leonardo Da Vinci's depiction of the Last Supper or see Michelangelo's detailed 'virtual sculptures' on the ceiling of the Sistine Chapel in the Vatican, Rome. As you will discover, it's possible to create 3D imagery

The artists of the Renaissance revolutionized painting through their mastery of colour, light and shading. Leonardo's fresco of The Last Supper *is a perfect example.*

in a 2D space using nothing more than some mineral and vegetable extracts and some weasel hair glued to a stick.

If there is a distinction between 2D and 3D in computer software, it is more because of the differences in the software used than any fundamental division between the results. Neither is really three-dimensional as such. When you paint a

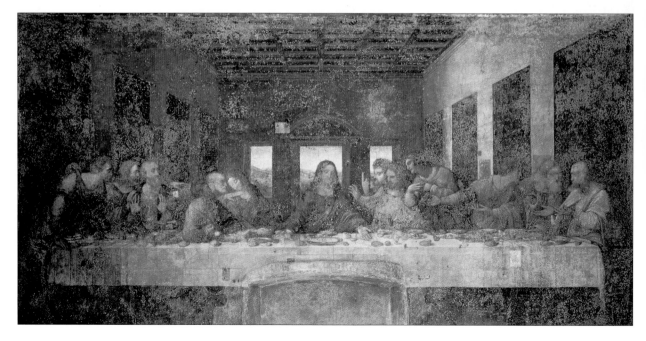

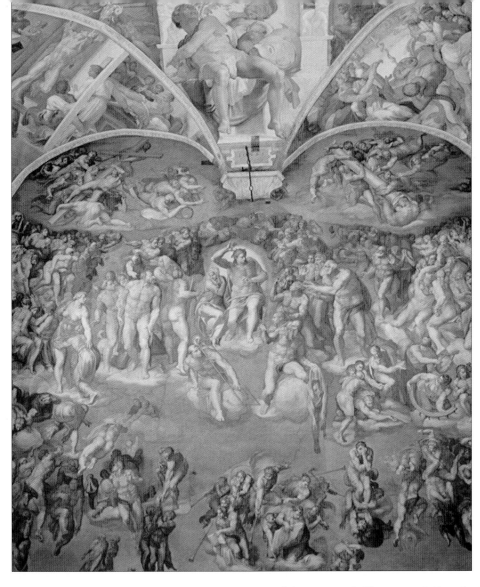

Michelangelo's bold frescos in the Vatican's Sistine Chapel work as stunning virtual sculptures. By the time he painted The Last Judgement *his grasp of what we might now call 3D imagery was truly unsurpassed.*

still life onto a flat canvas, you reduce the three spatial dimensions – up/down, left/right and in/out – by agreeing to take the first two at face value while discarding the third, which has to be simulated using the other two. By painting up and down and left and right on a flat canvas, you can create an image that also seems to go in and out.

It's our brain that does most of the work. As it's finely tuned to seeing all the three dimensions, the merest hint of them – even if one is just a simulation – sends it into calculative overdrive. Perspective is the key visual cue. By employing it, the artist can simulate more dimensions than a flat canvas allows. Add a hint of motion, a realistic facsimile of lighting and some deep shadows, and the effect becomes even more lifelike.

A 2D representation of a 3D scene can never totally fool the brain because our ability to see in true 3D is a result of our stereoscopic vision. Our eyes are on the same plane but placed slightly apart, thus producing the same image but from slightly different angles. The only medium capable of producing a 3D image, without additional gadgetry such as 3D goggles, is a hologram. But even if we never fool the brain completely, we can certainly create effects good enough to give a 2D image 3D impact.

And that's what this book is all about. Later on, we'll take a look at the fundamental concepts behind 'proper' 3D applications, but the projects before we reach that point should do more than convince you that superb 3D graphics can be created using regular 2D tools.

CREATING 3D FROM 2D

What really separates 2D and 3D computer software is the environment that you work in. The end result of both is merely a 2D image that simulates the real 3D world. In fact, 'simulates' is too strong a word; 'suggests' is probably a better way to describe it. The benefit of a 3D program is that, technically speaking, the images produced can be indistinguishable from photographs, at least in terms of perspective and lighting. Scientific accuracy, however, does not always result in pleasing aesthetics, and this is an important fact to remember.

It has been suggested that Vermeer made use of a pinhole camera to create accurate perspective in his paintings. Who cares? The ends certainly justify the means.

There's no need to think that producing 3D images in a 2D paint program is faking it. It is all fake. Whether you use a 3D program, such as Maya, or a 2D image-editor, such as Photoshop, the result is the same: a con, a trick, an illusion of reality. The only thing you need to worry about is acquiring the skills which enable you to recreate that elusive third dimension, depth, using just the other two.

Of course, drawing in 2D and taking into account only two dimensions can be very useful at times. Architectural and building plans do so for the sake of clarity. However, adding the effects of the third dimension results in a more interesting image, or at least a more natural looking one.

As we have already said, painters have been painting in 3D for centuries. While some had a natural talent for it,

others resorted to clever tricks. Take the famous Dutch painter Vermeer. His renderings of light and shadow are breathtaking, yet his images also have an unnerving clarity of perspective. Look at some of his paintings and you notice that there is something that they all have in common: each is painted in the same room. Why is this significant, you might ask? He might have liked the room or its light, or perhaps he was just lazy. Many have speculated, however, that he worked using a pinhole camera constructed in a closet-like box at one end of the room in question. The canvas hung in the box on the opposite wall to receive the perfect (though inverted) image of the tableaux, which he then traced. If so, this makes him one of the first 3D wizards.

Architects often restrict themselves to 2D representation for the sake of clarity. The standard 'elevation' and 'plan' drawings can be followed with greater accuracy.

Vermeer's mastery of light is beyond question, but he may have had aid from optical devices. Phillip Steadman's book, Vermeer's Camera (2001) covers the subject in some detail.

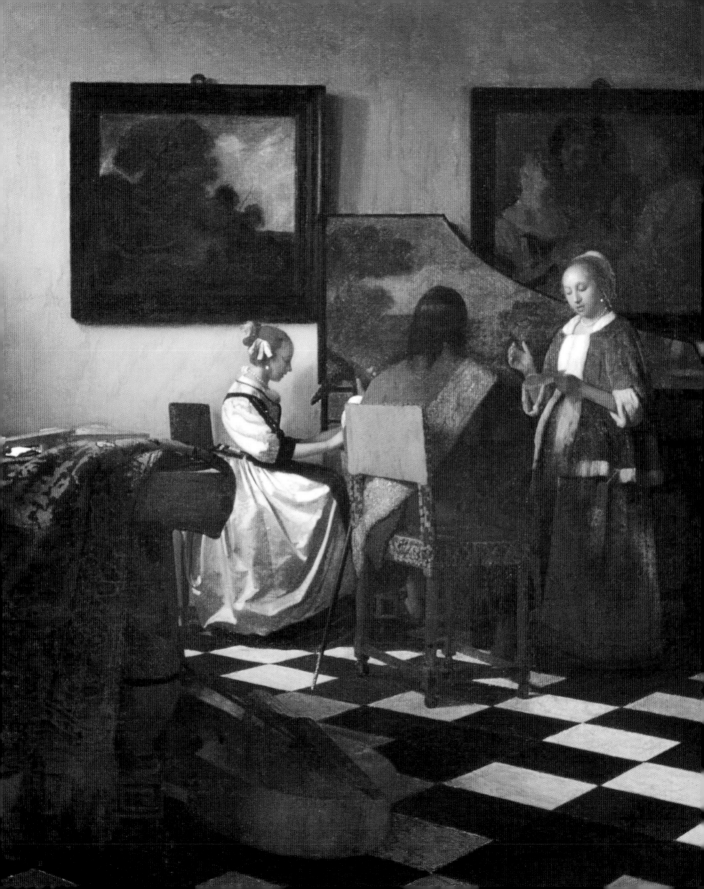

THE ILLUSION OF DEPTH

In order to recreate that elusive third dimension, you need to take into account some subtle and not so subtle visual cues. These include differences in shading due to the position and orientation of objects, the angle and position of light sources, and, of course, the effects of perspective. This latter property is probably the most fundamental, but it can be difficult to achieve accurately using a 2D program.

One of the simplest properties we can invoke to suggest depth in an image or graphic is shadow casting. A simple shape on a white background has no orientation with respect to its environment – there is no environment. Add the simplest of shadows, though, and the brain does its miraculous trick of providing one for you.

A simple shape on a white background is just that. Without any visual cue to its orientation, we can't tell if it is lying flat, standing upright, or just floating in the ether with other Platonic objects.

Adding a shadow immediately provides an environment – in this case a floor – and 'lands' the object on it, solidifying its position and orientation.

Suddenly there's a lot more information in an image with a shadow. There is now a floor, and we can also work out the object's orientation and position relative to it. There is a suggested source of illumination too, which also has a direction relative to the other objects. Most importantly, the inclusion of the

Add a basic shadow to this plain 2D rectangle, and the brain fills in the rest, transforming the shape into a 3D object, and the space beneath the shadow into a floor.

third dimension stipulates that a point of view is established. The image no longer represents an idea, but a physical scene, and we are looking at it. Possibly the single most fundamental result of adding depth to an image is that it defines the viewpoint of the scene.

When adding in all these details, it is important to be consistent. The brain can get easily confused if presented with conflicting information. This latter point has been exploited to great effect by artists such as M.C. Escher, who revelled in producing brain twisting images.

By confusing one of the many visual cues – in this case, perspective – while retaining consistency in others, such as light direction and shadowing, Escher produces an 'impossible' image that the human brain can't quite unravel. The human brain likes to make sense of things, and as it tries to juggle with the inconsistencies, the image looks both right and wrong at the same time. If you are not careful, though, images with inconsistent visual cues will simply look a mess.

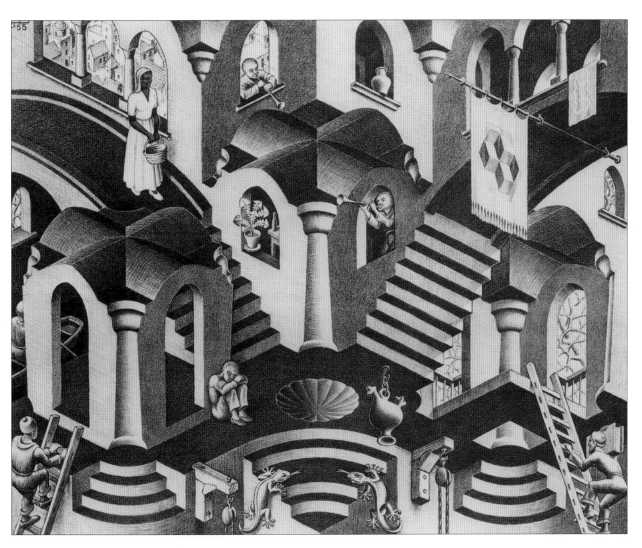

Escher's art is so effective because it obeys some of the rules of realistic 3D representation while wilfully twisting others. Here the lighting and shading is consistent, but the playful use of perspective brings everything into question.

When a shadow fits in with what we expect from reality, it adds to the impression of 3D. When shadows are placed carelessly the brain receives mixed messages, spoiling the effect.

METHODS OF PERSPECTIVE

Simulating perspective in a 2D application is relatively simple once we understand the basic principles. The first principle is that of the vanishing point used in linear perspective, a technique developed in the Renaissance. Take a square canvas, draw a horizontal line and a dot anywhere along it. This simple guide can be used to construct objects in perspective.

Hobemma constructed his painting of the Avenue, Middelharnis, using one-point perspective and a vanishing point, which accentuates the symmetry of the scene.

Draw a horizontal line, called the horizon line, and locate a point on it that is suitable for the vanishing point of the scene you want to draw. Objects can be constructed using this guide so that their parallel edges, if extrapolated, all merge at the vanishing point.

This one-point perspective technique, so-called because it has a single vanishing point, is very useful if you want to draw objects face on, but that is also its limitation. One-point perspective is useful only for objects that are face on to the viewer. To draw objects that are not face on you need to use two vanishing points – a method that we call two-point linear perspective.

With two-point perspective, we still draw a horizon line, but we then choose two vanishing points to lie on it. Guide lines are then drawn from the edges of objects to the vanishing lines to create accurate perspective.

Note that when using both one and two-point perspective techniques the vanishing points and horizon line do not necessarily have to lie within the canvas area

One-point perspective in action.

itself. To create a very low point of view, where the viewer is looking up steeply – perhaps at a towering object – the horizon can be placed off the bottom of the canvas. It also helps the effect if the vanishing points are set quite far apart from each other.

Two-point perspective.

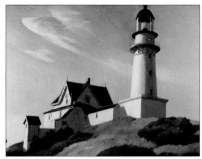

This Edward Hopper painting uses a combination of two-point perspective with a low point of view to superb effect.

In photography, different camera lenses can be used that have different focal lengths and therefore wider or narrower angles of view. A typical standard lens offers a view of 45–50°, while a fish-eye lens can produce much wider fields that approach 180°. Telephoto lenses have narrower fields of view, perhaps 25° or less.

Examine the illustration (below right). As the camera lens on the left has a narrower field of view than the one on the right, it can take in less of the 180° view available to it.

In actual fact, the narrow field of view results in a magnified image. The brighter blue area inside the lines represents the extent of the scene that will be captured on a frame of film in the camera. The right camera will give you a wider view of the scene, while the left offers a zoomed-in shot.

We can mimic these effects when we come to create 2D art. Just by moving the positions of the vanishing points, we can control the orientation of the view and also the 'focal angle'. Vanishing points set close together will create a 'wide angle' look, while widely spaced points create an image with less perspective distortion and a distinct 'telephoto' look.

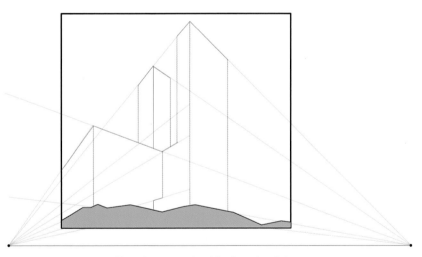

Two-point perspective with a low point of view.

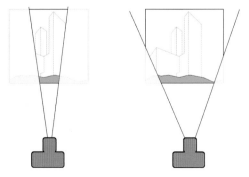

The effects of using a narrow (left) and wide (right) field of view.

2D VS 3D APPLICATIONS

While both 2D and 3D programs can be used to create 3D graphics, they are designed to work in very different ways. In a 3D program, you are actually working in a 3D environment. You must first build the 3D scene or object so that you can subsequently 'render' it as a 2D piece of artwork. In a 2D program, you create that final image directly, working in a 2D environment to create an image of a 3D object or scene.

This image has many properties we associate with rendered 3D images – transparency, texture, realistic lighting and shading – yet it was created entirely in Photoshop.

The 3D program uses a virtual 3D environment in which you create 3D objects, apply surfaces and assemble them into a scene for the final rendering process. While the process is logical, it is complex and it can take some time to get used to this way of working; your first efforts often look clumsy. If you are used to 2D tools, you could easily find this frustrating.

The 2D drawing or painting application is a more natural tool for traditional artists. The environment is more familiar, with a canvas on which you work using tools such as brushes, pens and masks.

Both methods have their pros and cons. If you want to do highly realistic images or create animations with depth a 3D program is the way to go, and it doesn't take much thought to make that decision. The other thing about 3D programs is that, because you create the 3D scene and objects in a virtual 3D space, technical properties such as perspective and shadow casting or more complex effects such as accurate surface reflections and transparency will be taken care of automatically. Creating reflections and transparency in a 2D program is possible (see p98) but it can be tricky, and with complex shapes the task is nearly impossible.

3D applications are complex and take time to learn. Before you can start building complex scenes, you might need to practise with some more basic examples.

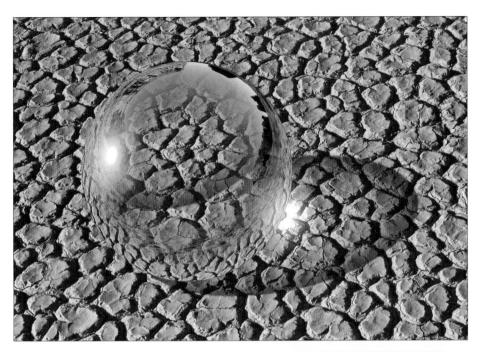

This image of a glass ball on a parched-earth landscape was created using nothing more than Photoshop. See how on pp 98–101.

Apple's 'gel' buttons are quite straightforward to create in a 2D painting program but much less so in a 3D application (see pp 78–9).

The strength of 3D applications is the way that they create realistic 3D surfaces, complete with lifelike shading and reflections.

However, creating 3D graphics in a 2D program has a couple of major benefits. Firstly, if you are already familiar with Photoshop or another 2D program, you will have no learning curve. All you need to learn are the techniques. It can also be much quicker to produce a small simple graphic (e.g. a Web button) using Photoshop than it would be to make it from scratch in 3D.

Sometimes the accuracy of a 3D program can be its downfall. For example, take a typical 'gel' button or graphic element such as those used by Apple on their website (www.apple.com). It is relatively simple to create the gel button look in Photoshop or Corel Draw, but to do the same in a 3D program would be quite tricky. You would need to define a surface material that had the correct gel-like properties and you would also need to create an environment for the button to reflect. Finally, the lighting would need to be devised so that you get the long smooth highlight.

2D APPLICATIONS

This book will take you through a number of techniques and methods to create 3D graphics and artwork using both 2D and 3D tools. The 3D section covers the basics of what you need to know and looks at current 3D technology, hardware and software. For now, we will look at the 2D programs available, and how they can help you to work through the example techniques used in this book.

2D programs can be broken into two broad categories: bitmap and vector-based applications. Bitmap applications work with grids of coloured pixels to produce their images. The most important consequence of this is that they are resolution dependent, which means – in practical terms – that you need to decide how large your canvas has to be before you start to create your image. If you do not, your image will not look its best when displayed at your chosen size on your chosen medium. For print work, you need higher resolutions, which means a lot of pixels and therefore a lot of data. The more data, the longer any complex operation, such as applying a filter or resizing the image, will take. Web graphics, however, are displayed on a computer monitor, which means that a lower resolution and fewer pixels will suffice.

Vector programs store artwork as a series of curves, lines and fills, which are defined through mathematical instructions. The advantage is that they are resolution independent – you can scale the final artwork to any size and it always looks its best.

▲ **BITMAP** For a bitmap image destined for print, make it the right resolution from the start. You can't scale it up afterwards without damaging the image quality.

▲ **PHOTOSHOP** After many years, Adobe Photoshop remains the dominant bitmap editing and painting tool. As far as most graphics professionals are concerned, it is by far the most complete and satisfying 2D artwork package available.

▲ **VECTOR** Vector artwork, on the other hand, can be scaled without loss of quality because the curves are stored as mathematical instructions rather than as pixels.

▲ PHOTO-PAINT Corel Photo-Paint is a very good bitmap editing program that works along the lines of Photoshop. Like Photoshop, it runs on both Macs and PCs.

▲ CANVAS Deneba Canvas is a hybrid 2D tool that combines bitmaps and vector graphics in a single package. While Photoshop offers simple vector paths in combination with full bitmap capability, Canvas's object-based approach integrates the two seamlessly.

▲ ILLUSTRATOR Adobe Illustrator is the company's vector illustration package. The industry standard for vector graphics creation and editing, its advanced features, such as gradient meshes and artistic brush strokes, produce amazing art.

▶ FREEHAND *Macromedia Freehand is another popular vector artwork package. It often feels less complicated than Illustrator and the latest version runs on Mac OS X too.*

CREATING 3D EFFECTS IN 2D

The projects in this chapter will ease you into the 3D world. They focus on providing easy ways of adding an illusion of depth to 2D art to create strong graphics that seem to stand out from the page or screen. We begin with basic effects, such as shadows, simple shading and subtle textures, then move on to show you how you can employ them in exciting and imaginative ways. We then tell you how to simulate a variety of metallic surfaces and use common filters to create effects of lighting and relief. Finally, we will show you how to recreate shading effects that turn flat textures into realistic surfaces.

The examples in this chapter all use Photoshop, but most of these techniques can be replicated in other image-editing applications, even if the actual features used will differ. The results might only be 'pseudo-3D' rather than the real thing, but they give you a taste of how easy simulating 3D can be, and provide a solid basis for the advanced projects that come later.

BASIC DROP SHADOWS

Adding a shadow is the simplest way to add depth to a graphic element, and the drop shadow is probably the easiest shadow to add. This trick has been used by graphic artists for years to add emphasis to text or an image and lift it off the paper, and it is very simple to do in a program such as Photoshop or Corel Photo-Paint. Photoshop itself now allows you to create drop shadows interactively using Layer Styles (see pp 26–7), but there is a manual method that is just as quick. As a bonus, it will also work in older versions of Photoshop and most other bitmap image-editing applications.

▲ 1 The first step is to create whatever it is that you want to cast the shadow. In this example, it is a simple type element from the Zapf Dingbats type face. The important thing is to make sure that you create the artwork on a transparent layer above the background.

▲ 2 As the number is a live text element in Photoshop, it's already on its own transparent layer. Another layer is created below it, and it's this layer that will house the drop-shadow once it's created. You now need to load the type layer as a selection. Control/Right-click the type layer (depending on whether you're a Mac or PC user) and choose *Select Layer Transparency,* or simply Command/Ctrl-click (Mac/PC) the layer.

▲ 3 The shadow layer will be highlighted in the Layers palette and the outline of the type will be selected. Making sure that black is the foreground colour, you can now fill the selection with black by using the *Edit>Fill* command. The type layer is turned off here so that you can see the result.

▼ 6 Finally, adjust the *Opacity* of the shadow layer. Faint shadows can work quite well, but traditionally a drop shadow has an opacity of around 75%.

▲ 4 Next, making sure there is no selection active (Command/Ctrl-d in Photoshop), the shadow layer is blurred to create the soft-edged drop shadow. Choose *Filter>Blur>**Gaussian Blur**￼* and adjust the *Radius* slider to the desired level (7 pixels in this particular case).

▲ 5 The final effect is to offset the shadow layer from the object casting the shadow, by using the *Move* tool. Do this in the opposite direction to that in which the light is supposedly being cast from. Typically this would be top left or top right, in which cases the shadow layer is moved to the bottom right or bottom left respectively. The further you move the shadow, the higher the object will appear to float. You can compensate for a larger offset with more blur.

SIMPLE 3D SHADING

To complement drop shadows, you can add simple 3D shading to your 2D objects. When an object is illuminated from one direction by a strong light source, its surface exhibits areas of shading. These are referred to by digital artists as highlights and shadow areas. Depending on the kind of material the object is made from and the brightness of the light, these areas will vary in their intensity and sharpness.

A hard, shiny object will have well-defined highlights, whereas a rough, matt object's highlights will be much broader and less well defined. We can simulate this on simple shapes in Photoshop to create objects and icons with more depth and contour.

▲ **1** Here's our starting point – another simple type element. When designing a shape that will have contour shading applied, be careful not to choose one that is too skinny. Doing so will limit the degree of offset you can apply, and therefore limit the depth of the effect.

▲ **2** Apply a drop shadow as before, loading the type layer as a selection, filling it with black on a transparent layer below and then blurring and offsetting the result.

▲ **3** Add another layer, this time above the text object, and fill it with white. Now load the outline of the text object as a selection and fill it with black in the new layer, then apply a *Gaussian Blur*. The amount of blur that you apply will define how rounded the edges of the object will appear.

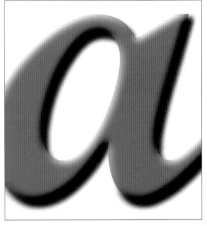

▲ **5** The blend mode of the embossed layer can be set to *Overlay*, *Soft Light* or *Hard Light,* to alter the effect. *Hard Light* will keep the white and black but make the greys disappear, while *Overlay* will tend to merge the white and black with the colour underneath. *Hard Light* looks more like plastic, while *Overlay* gives the object a more metallic look.

▼ **6** Once again, load the type layer as a selection, but this time apply it as a layer mask to the emboss layer, so that it cuts off any overspill. The intensity of the shading can be altered by adjusting the *Opacity* slider. We can also exert independent control over the white and black portions by applying *Levels* to the embossed layer and adjusting the black and white output slider. The gamma slider (the grey triangle in the *Input Levels* section) is then used to readjust the grey point to compensate.

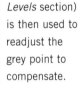

▲ **4** We now apply the *Filter>Stylize> **Emboss*** filter. This creates a highlight and shadow area for the contour or relief effect. Don't forget to set the angle to the same direction as you offset the shadow layer.

FAKING DEPTH

The next step is to add some depth to your 2D object, and one way of doing this is to add a simplified perspective, turning your flat image into something with sides. With basic, flat objects like text, you can do this using nothing more advanced than Photoshop's Motion Blur filter. Your new 3D text might not obey the correct rules of perspective, but it will have a chunky 3D thickness to it.

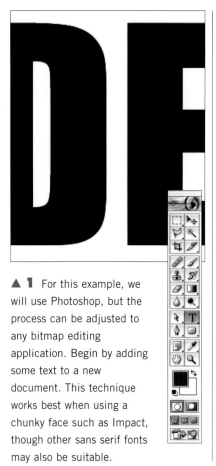

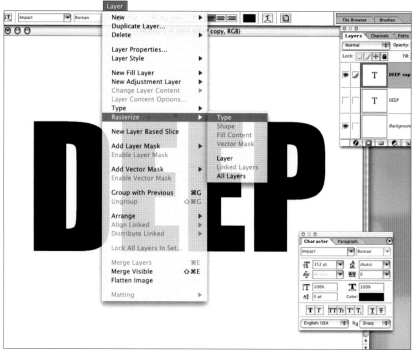

▲ **1** For this example, we will use Photoshop, but the process can be adjusted to any bitmap editing application. Begin by adding some text to a new document. This technique works best when using a chunky face such as Impact, though other sans serif fonts may also be suitable.

▲ **2** The text layer is duplicated by dragging the type layer down onto the new layer icon in Photoshop's *Layers* palette. Now convert the duplicate layer into a straight pixel layer by using the *Layers>Rasterize>Type* command. The visibility of the original type layer will be turned off.

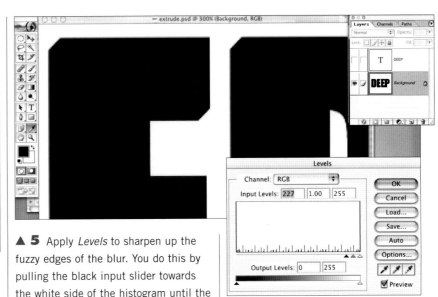

▶ 3 Because the only two visible layers are the white background layer and the rasterized text, we can use the *Merge Visible* command from the *Layer Option* menu (the triangle at the top right of the *Layers* palette) to combine these two. As the type layer is not visible, it remains separate and editable.

▲ 5 Apply *Levels* to sharpen up the fuzzy edges of the blur. You do this by pulling the black input slider towards the white side of the histogram until the blurred text becomes almost solid black. By repeatedly blurring and levelling the merged layer, you can continue until you reach the desired depth.

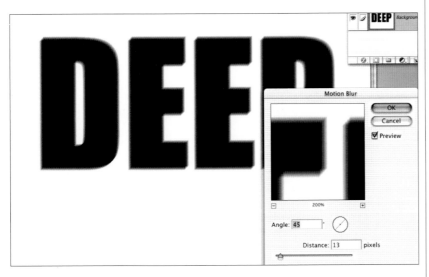

▲ 4 The reason for the merging will be clear in a moment. But first, the magic bit. Select the merged layer and apply *Filters>Blur>**Motion Blur** to it. Set the angle to the desired angle of the extrusion – 45° is usually a safe bet –

and apply a small amount of blurring, perhaps 10 pixels. The settings will depend on the resolution of the document and the size of the text, but you want to watch that the edges do not deteriorate too much.

▲ 6 Now make the live type layer visible again. Change its colour to something other than black and then use the *Move* tool to position it in the bottom corner of the text, or the upper corner if you want the text to look as if it is viewed from below. *Et voilà* – 3D extruded text!

LAYER STYLES

Back in the early days of computer graphics, Photoshop artists like Kai Krause used selections and sophisticated channel operations to achieve stunning 3D effects, from drop shadows to cutouts and bevels. These days, there's an easier way. The Layer Styles feature introduced in Photoshop 6 enables you to add all manner of 3D effects to 2D objects, and keeps those effects 'live' so that you can return and tweak them whenever you please.

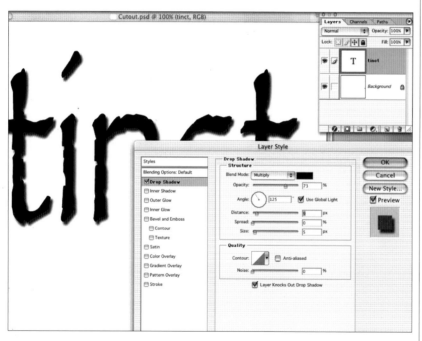

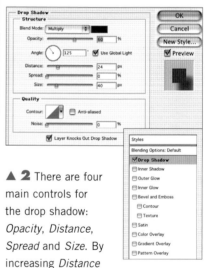

▲ **1** You can apply *Layer Styles* just by choosing *Layer>Layer Styles>.....* and then one of the style effects from the menu list. We will begin with something simple: the *Drop Shadow* option. Up pops the *Layer Styles* dialog, which is quite a big panel. What you get is an instant drop shadow – much quicker than using the manual method described earlier in the book (pp 20–1).

▲ **2** There are four main controls for the drop shadow: *Opacity*, *Distance*, *Spread* and *Size*. By increasing *Distance* and *Size,* you can create some nice subtle diffuse blurs that look a lot less clichéd than the standard drop shadow. While the effect is still a simple parallel drop shadow, it has a slightly more modern look about it.

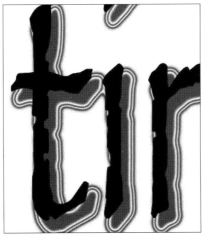

▲ **4** Changing the Contour option can create some pretty wild, stylized results. They might not be truly 3D, but they are still interesting and quite fun too. There is no way that you could describe this drop shadow as hackneyed.

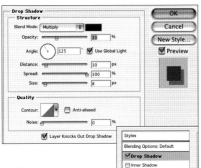

▲ **3** By increasing the *Spread* slider to 100% and adjusting the *Distance* and *Size* sliders, we can create some pseudo-3D chunky text. The trick is not to let the shadow appear to separate from the type layer. Maintain control by adjusting the *Distance* and *Size* sliders in combination with the *Light Angle.* The kind of font used will have a bearing on matters too.

INNER SHADOWS

You can also use Layer Styles *to add depth behind an image. In this case, we have applied the* Inner Shadow *layer style to a simple graphic image of a skull. The background has been set to white, and a darker* Color Overlay *layer style has been applied to the skull.*

Increasing the Distance *and* Size *sliders will make the background layer appear to rise above the skull. To add further thickness, apply the* Outer Bevel *layer style, making sure that you have the* Global Light *option enabled in both the bevel and shadow sections.*

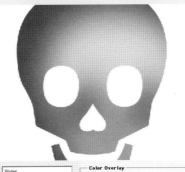

ADDING TEXTURE

Another quick way of giving 2D objects a 3D feel is to replace their flat colours with textures that mimic the rough, smooth or reflective appearance of objects in the real world. Again, Layer Styles comes to the rescue. Bevel and embossing options help to create the impression of relief, then the Layer Styles palette allows you to add textures to those surfaces for some truly exciting results.

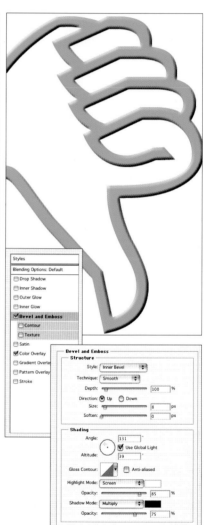

▲ **1** Our subject is created using a live text layer in Photoshop. The essential ingredients are the transparent pixels in the layer. Whether you draw on the layer by hand or import some vector artwork, the *Bevel and Emboss* layer style needs an edge in order to work. If you draw onto the background layer or on a filled, floating layer, there will be no edge around the graphic to emboss. The perimeter of the layer will be used instead, which won't give the desired effect. Make sure that your object sits on its own in a transparent layer.

▲ **2** The first thing to do is fill the object with the colour of your choice. This can be done in the live type options, but you can also do it using the *Color Overlay* section of the *Layer Styles*: select *Layers>Layer Styles> Color Overlay.*

▲ **3** Enabling the *Bevel and Emboss* option allows you to set a wide variety of relief effects. In this case, we will look at the *Inner Bevel* option, which creates the bevel within the object itself. Other options such as *Pillow Emboss* will also attempt to emboss the background.

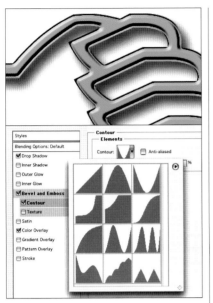

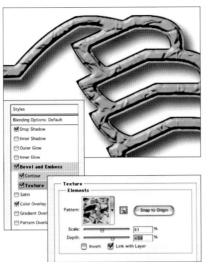

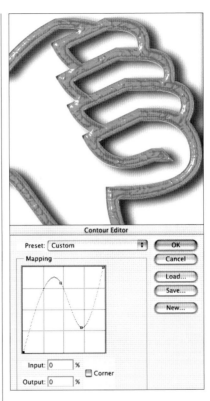

▲ **4** The *Contour* section uses a graph that modifies the shape of the bevel. Clicking on the pop-up menu displays a selection of presets, but you can also design your own. The one we have chosen creates an outer ridge and an inner hump for a more detailed relief effect. We have added a *Drop Shadow* at this point too.

▲ **5** Enabling the *Texture* section of the *Bevel and Emboss* effect creates undulations of the surface of the object, much like bump mapping in a real 3D program (see p130). You can choose any of the stored patterns from the *Pattern* pop-up menu, and you can create your own by making a selection and choosing *Edit>**Make Pattern***. The strength of the effect can be modified using the *Depth* slider and the scaling using the *Scale* slider.

▲ **6** The shiny almost gel-like quality is created by subtly tweaking the settings. First the shadow area *Opacity* is reduced, then the shading contour graph is edited to make a double hump.

▶ **7** The texture *Depth* is reduced for a more subtle surface bump, and finally the *Lighting Angle* is edited. This has the most bearing on the appearance of the highlights, and there is a fair bit of interaction between the shape of the contour graph and the light angle. Experimentation is the key.

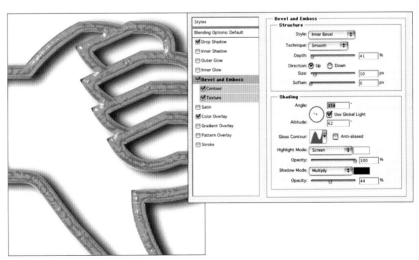

SIMPLE CHROME

Bevelled and textured surfaces are perfect for adding relief to a 2D object, but you can go further and work with reflective, metallic surfaces. There are many different metal effects that you can create in a bitmap-editing application, but chrome and its variant gold are probably the most frequently needed. There are many different ways to create chrome, but it can be difficult to create a lifelike reflection. One process is quite effective, however, and Photoshop is the ideal tool with which to do it.

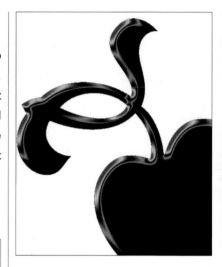

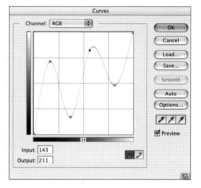

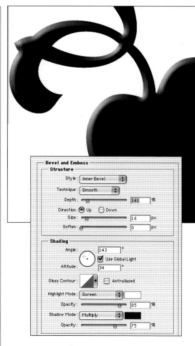

▲ **1** The usual candidate for the chrome treatment is a logo or some type. A single icon like this is actually the trickiest to get right, and the less detail the shape has, the trickier it gets. Generally speaking, the more ornate the object, the more convincing the effect.

▲ **2** First, give the object some 3D depth by using *Layer Styles* to add a bevelled edge with the *Inner Bevel* option. The exact settings are not important at the moment.

▲ **3** The metallic sheen is provided by a *Curves* adjustment layer (*Layer >New Adjustment Layer>**Curves***). Edit the graph to make a 'mountain range' profile. Two dips and two troughs are sufficient.

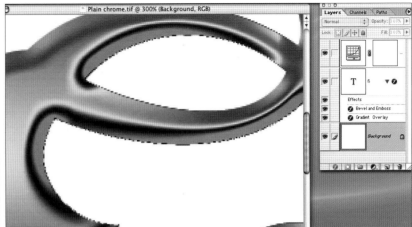

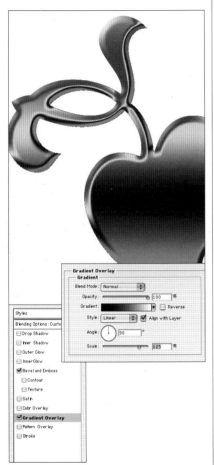

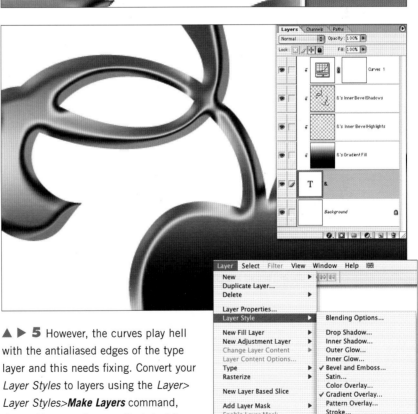

▲ **4** The chrome reflection is supplied by a *Gradient Overlay* in the *Layer Styles*. For this example, we will use a simple black-to-white gradient applied at 90°, which interacts with the curves to give a rich metallic lustre.

▲ ▶ **5** However, the curves play hell with the antialiased edges of the type layer and this needs fixing. Convert your *Layer Styles* to layers using the *Layer> Layer Styles>***Make Layers** command, then add a new *Curves* adjustment layer to the clipping group by Option/Alt-clicking (Mac/PC) the divider between it and the layers below.

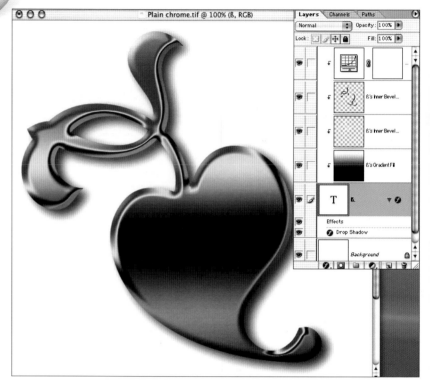

▶ **6** Now add a drop shadow to the type layer using *Layer Styles* once more. If we had done this before creating the layers, the *Curves* adjustment layer would have made the shadow stripy too.

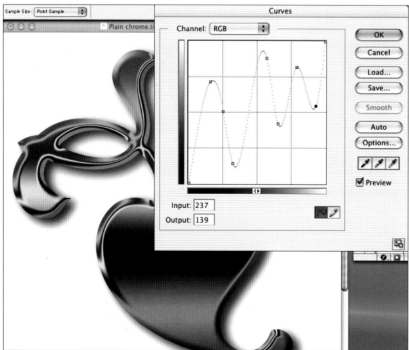

◀ **7** By editing the graph in the *Curves* adjustment layer, adding extra peaks and valleys, we can make the chrome striping effect more intense. The reverse is also true: removing points will smooth the chrome effect out.

TIP *If you want to emulate other metals, such as gold, you can add first a* Levels *then a* Hue/Saturation *adjustment layer using the object's outline as a mask. Decrease the contrast in* Levels *by dragging the black and white* Output *sliders, and in* Hue/Saturation *enable the* Colorize *option to set the desired gold, bronze or copper tone.*

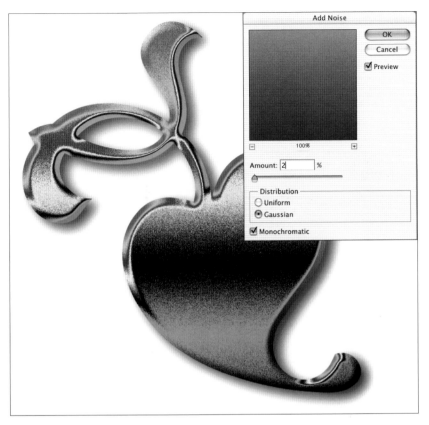

�DELETE◄ ▼ **8** Surface imperfection can be added by applying the *Add Noise* filter to the gradient layer. This can then be blurred to create subtle ripples in the surface of the metal. Try reducing the *Opacity* of the gradient layer to adjust how the simulated reflections appear.

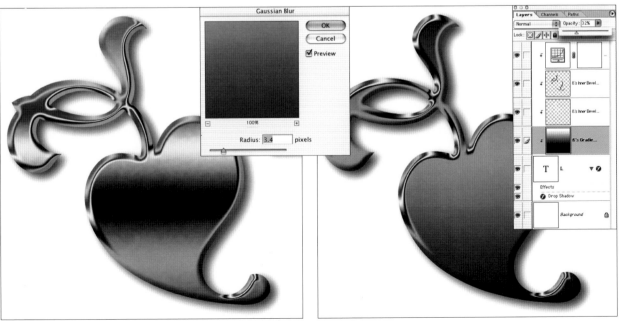

LIQUID 3D TEXT

One of the great things about Adobe Photoshop is that you can create some very interesting 3D effects without much actual painting, drawing or selection work. For example, a bit of imagination and a lot of help from the Filter menu lets us produce some interesting liquid text effects.

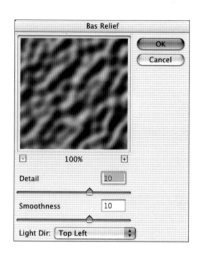

▲ **3** The trick to creating this mercury effect is to apply the Bas Relief filter (*Filter>Sketch>Bas Relief*). Use values of 10 for *Smoothness* and *Detail*, and set the *Light Direction* to *Top Left*.

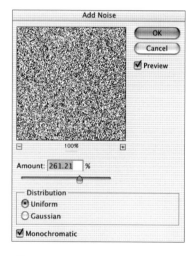

▲ **1** Create a document 1024 x 1024 pixels in size and fill it with a large amount of noise (*Filter>Noise> Add Noise*). Any setting over 200% should be fine.

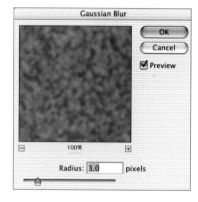

▲ **2** Soften the Noise using a *Gaussian Blur* with a value of 3.0. This creates the sort of blurry noise that is often used as the starting point for Photoshop special effects.

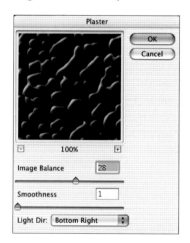

▲ **4** To convert this into Mercury, apply the *Plaster* filter (*Filter>Sketch> Plaster*). This doesn't sound like it could create metallic effects, but by setting the *Light Direction* to *Bottom Right* and using a low *Smoothing* value, you can adjust the *Image Balance* slider until metallic drops appear. Make sure that the foreground and background colours are set to default with black on top.

TIP *The origin of this mercury effect is the method of reapplying the same filter twice or more. In fact, it's not really a method as much as a good habit to try. Sometimes miraculous things happen when you combine filters or apply them multiple times, or a new effect emerges that gives you a clue about how to tackle some other effect. It's all part of the learning process. Store the results in your memory, and you will be surprised how you can retrieve them at some point in the future.*

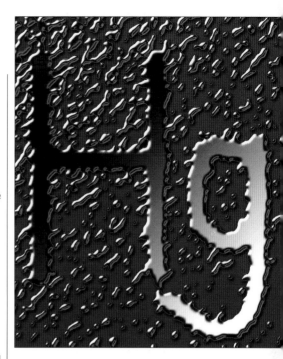

▲ 5 That's the basic procedure; now we will undo the *Plaster* filter and add our text. Using nothing more fancy than a large soft brush, we paint the text on a new layer in white. Notice that the *Bas Relief* filter produces a slight gradient in the light direction. If you want your text to be well separated from the beads, paint in the darker corner of the image. *Crop* away what isn't needed.

▼ 6 By selecting all and using Command/Ctrl-Shift-c, we can copy a flattened version of the layers, and paste this as a new layer. This simply allows us to experiment more easily without having to run the *Flatten* command. The *Plaster* filter is applied to this layer, and the *Image Balance* is used to adjust the amount of mercury. Don't forget to switch back to the default colours with black on top.

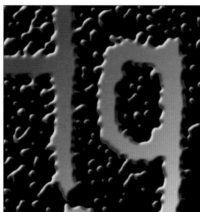

◄ ▼ 7 To make the beads more metallic, we can apply *Curves*. A double-hump curve remaps the brightness values for a more metallic reflection.

▲ ▼ 8 Going one step further, we can select the black background and remove it using a layer mask, and then add a solid colour background. Using *Layer Styles* will add a shadow, but cunningly we also reflect the backdrop in the beads by using only the *Shadow* portion of an *Inner Bevel*. This is coloured the same as the background and set to the *Color* blend mode.

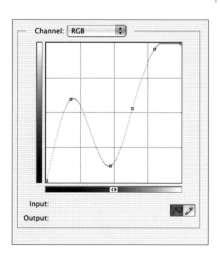

35

ROUGH CAST METAL

Having produced shiny chrome and liquid metal textures, we can use similar techniques to create other surfaces. In this instance, we will create a cast metal look for a logo. By combining a smooth machined metal look with the roughness of cast metal, we create textural contrast in the final image. This not only helps artistically but provides extra visual cues that will make the end result believable and add that elusive feeling of depth.

▲ **1** This is the logo for the rough cast metal effect. It is a good starting point because the logo is nice and chunky. Always be careful to match an effect to the subject matter. This one would not suit an ornate design: in the real world, complex shapes are not made by casting and machining. We want our object to look like it has come out of a foundry.

▼ **2** We create the logo from simple vector shapes. Add a new layer, then load the shape layer as a selection. Now, using *Selection>Modify>***Shrink**, contract the selection by 24 pixels and apply as a layer mask to the new layer. Fill the result with white.

▼ ▶ **3** Once again, the starting point of our metallic texture is a large amount of noise (*Filter>Noise>***Add Noise**). Check the *Monochromatic* box, increase the *Amount* to over 300% and set the distribution to *Gaussian*. This gives us the start of the rough, cast-iron texture. Now blur the noise using *Gaussian Blur* with a *Radius* value of about 4 pixels for this 2500 x 1800 pixel image. Do not worry too much if the edge of the mask has also blurred. Just cancel the filter and unlink the mask from the layer by clicking the chain icon in the *Layers* palette. When you re-apply the *Blur,* the mask should remain sharp.

▼ 4 The next step in creating the casting texture is to apply the *Filter>Sketch>**Bas Relief*** filter to the noise layer. Using maximum *Detail* and a low *Smoothness* with a *Light Direction* set to *Top Left* (or *Top Right*) produces an embossed-like bump.

TIP *There is an easy way of adding more impact to your rough cast metal logo. Turn to pages 54–5 to learn how to extrude an object and add realistic shading at the same time. Try following the steps in that project after you have created the front of the cast metal object, as detailed here. Once you have finished this project, merge the layers into a single layer that can be transformed. Then use* Free Transform *to distort the cast layer into the desired angle and perspective. Use this outline as the extrusion outline, then add some shading and extrude, and your rough cast metal logo will have an even greater sense of depth!*

▲ ▶ **5** To finish off the cast look, we can apply a *Bevel and Emboss* layer style to the noise layer. Use *Inner Bevel* and set it to the *Down* mode, which makes the edges of the cast area appear to rise up slightly while the centre dips away. *Texture* is enabled and the second pattern is chosen; a kind of fractal noise. The interaction between this and the *Bas Relief* filter effect creates the cast metal texture.

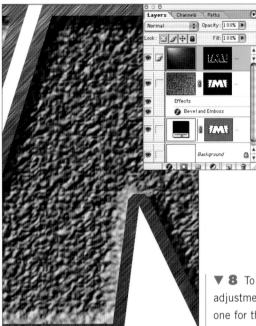

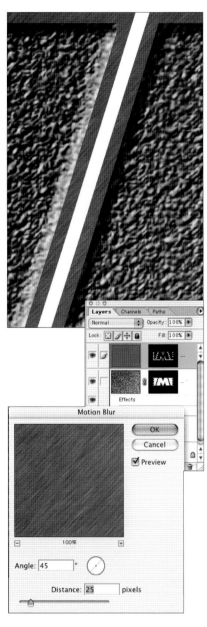

▲ **7** Apply the *Lighting Effects* filter (see pages 44–5 for details) to the noise layer using the *Green* channel as the *Texture Channel*. This provides some depth to the metal grain.

▼ **8** To finish off, add two *Levels* adjustment layers, each with a mask: one for the machined edge, one for the casting. Adjust the *Input Levels* independently to achieve a more metallic look. To finish, apply *Lighting Effects* to the background layer, setting the style to *Illumination*, and add a *Drop Shadow* layer style to the logo.

▲ **6** Select the edge boundary of the logo and add it as a layer mask to a new layer. Fill the mask with 50% grey and then *Add Noise* at a low *Amount*. Make sure that mask and layer aren't linked, then use *Motion Blur* in the opposite direction to the *Bas Relief* in Step 4.

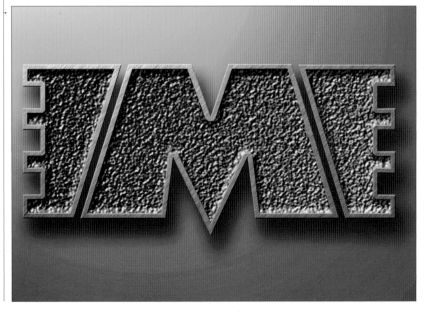

CREATING A GILT FRAME

We can also use existing imagery to create 3D effects. In this exercise, we'll look at how to expand a single tiny photographic element into a full 3D object. This photo of a small gilt carving can be converted into a 3D picture frame using a procedure that should work in nearly any bitmap image-editing application.

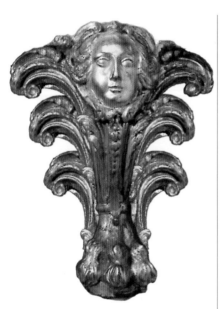

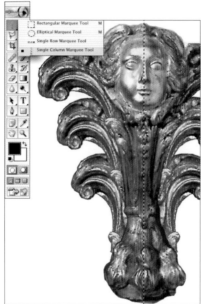

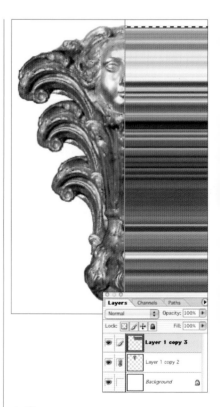

▲ **1** Here's the image we will use. It's a small gilt carving, and despite its size has plenty of detail in it. It's the detail in the image that creates the shading in the frame, so we need a good level of it for an effective result.

▲ **2** The first step is to make sure the image has a transparent background, so delete any extraneous pixels outside the object, either by using the *Eraser* or the *Lasso Selection* tools, and copy the image to a new transparent layer. Next, make a duplicate of this layer, then use Photoshop's single-pixel vertical *Marquee* selection tool, with the *Marquee* positioned straight down the object's centre.

▲ **3** Now use *Free Transform* to expand that single column of pixels horizontally. Notice that the detail in the carving is stretched across the frame. Just as importantly, the same goes for the lighting information.

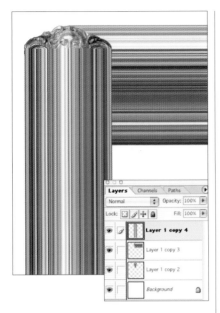

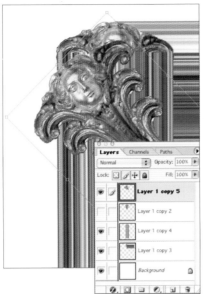

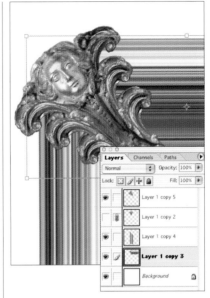

▲ **4** Duplicate the original object layer once more and this time use the horizontal single-pixel *Marquee*. Position this across the widest part of the object and use *Free Transform* to extend the pixel row vertically.

▲ **5** Make another copy of the carving layer and move it to the top of the stack. Use *Edit>Transform>***Rotate** to rotate the carving by 45°, then position it so that it joins the two segments of the frame.

▲ **6** Delete the portion of the vertical frame above the corner carving. To fix the horizontal section, we need to scale it vertically. This will hide any unwanted portions behind the corner carving, but if any bits do show up, just erase them.

◄ **7** That's the corner section completed. This can be merged to a single layer, then copied and rotated to form each corner of the frame. Finally, add a picture of your choice, perhaps your best artwork, and apply some drop shadows to finalize the effect. If you want to be really picky, you can flip the bottom and right edges so that the highlights are all facing the right way. You can do the same with the carvings.

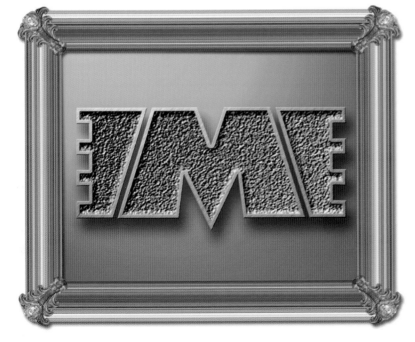

3D SCULPTURE EFFECTS

There are some 3D techniques that are not exactly useful for everyday artwork, but are fun to do and can produce unique or distinctive effects. This next example is a case in point; it is so simple and fun that you could spend hours just fiddling around creating intricate sculpted surfaces. It uses nothing more than a gradient and Photoshop's Twirl filter.

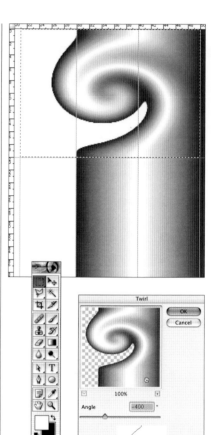

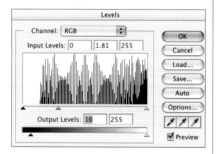

▲ **1** Make a rectangular selection in a new layer and use the *Gradient* tool in *Reflected* mode to build a tube. Adjust the shading with *Levels*. Pull the black point in and move the midpoint to the left so the light portion of the gradient spreads across the tube's width.

▲ **2** Duplicate the tube layer (twice – keep a copy safe in case you need to redo things) and move it so that you have two pipes butting up against each other. Add a few guide lines to help with the selections that you will draw later. The layers are linked and merged to a single layer (choose *Merge Linked* from the *Layers* palette's options menu).

▲ **3** We now draw a selection at the top left of the tubes. It is important to get the selection right because it affects the whole way in which the scroll will look. The centre of the selection is where the centre of the scroll will be. We then apply the *Filter>Distort>Twirl* filter, with the *Angle* set to -400. The result is our first sculpted scroll.

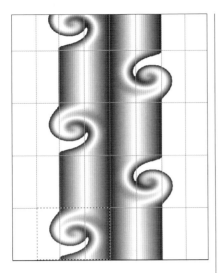

◀ **6** The two tubes are interlocked using a series of smaller selections and less intense twirls that span the centre line. You can carry on and add as much detail as you like by moving selections and applying the filter.

▲ **4** Now move the selection to create a series of scrolls alternating down both sides of the tubes. To apply the *Twirl*, type Command/Ctrl-f.

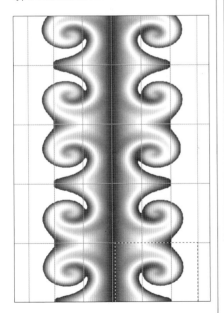

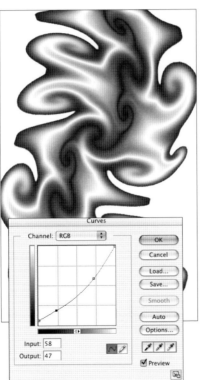

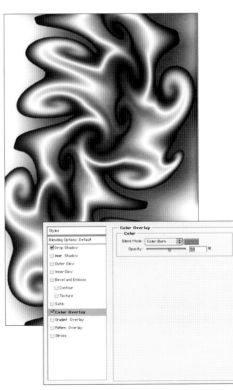

▲ **5** Fill in the gaps with another *Twirl* but this time set the *Angle* to 400 instead of -400. This makes the scrolls twist in the opposite direction.

▲ **7** Here we have added some smaller scrolls at the extremities and then distorted the whole thing with a very small amount of *Twirl* to keep things looking organic. Apply a *Curves*

adjustment layer and a *Color Overlay* layer style to give the sculpture a metallic sheen. You could try this technique with different starting shapes to get different designs.

LIGHTING EFFECTS

Lighting Effects is a Photoshop filter that is normally used to simulate the effects of a light or multiple lights shining onto your artwork. The interface is fairly complex, with multiple controls to adjust the colour and intensity of the lights and the material properties of the surface being illuminated. But while it can be tricky to get to grips with, this filter will reward your efforts, thanks to a small but powerful section for adding 3D relief to your artwork using stored alpha channels.

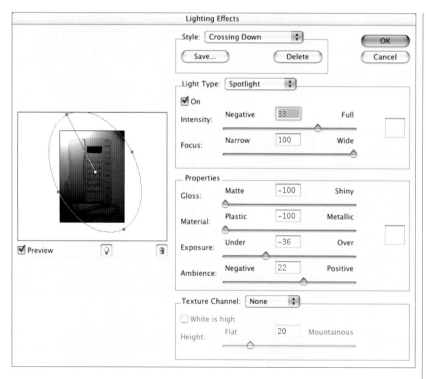

▲ **1** *Lighting Effects* bathes your 2D art in pools of light. At first, it seems like there is not much that you can do with the filter apart from the obvious.

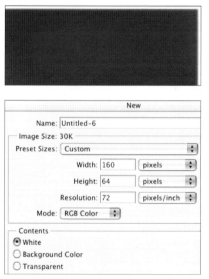

▲ **2** However, *Lighting Effects* can be used as a tool for creating 3D effects. Its speciality is relief-dependent effects, such as bump maps, simple buttons and 3D text. In this example, we will use *Lighting Effects* to make an image of a wall look more 3D by giving it surface bumps. First, make a single brick from a 128 x 64 pixel RGB image.

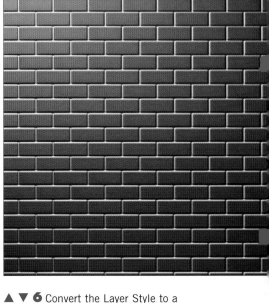

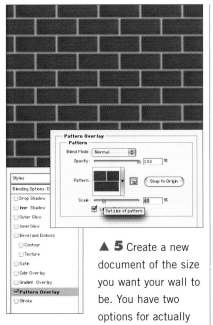

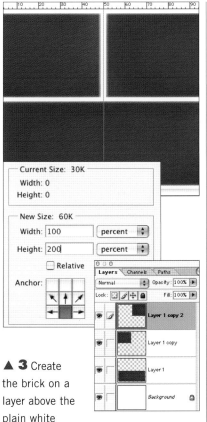

▲ 3 Create the brick on a layer above the plain white background. Double the Canvas Area vertically using *Image>**Canvas Size*** with the *Height* set at 200%. Now duplicate the brick layer twice and move the new bricks into position, offset by 50%. Enabling rulers and guides can help. Note that the middle mortar gaps are twice the size of the edge gaps.

▼ 4 A suitable mortar colour is chosen for the background, then the image is flattened. The whole document area is selected then saved as a pattern using the *Edit>**Define Pattern*** command.

▲ 5 Create a new document of the size you want your wall to be. You have two options for actually building it. The first is to use the *Edit>* ***Fill*** command and choose the *Pattern* option, then your wall pattern. A better way is to use *Layer Styles*. The background is first converted to a layer, then a *Pattern Fill* layer style is applied. Choose the *Brick Wall* preset and your wall appears. Unlike the *Fill* command, you have the option to scale the pattern to create the density of bricks you want.

▲▼ 6 Convert the Layer Style to a normal layer (*Layer>Layer Styles>**Make Layers***), then apply the *Lighting Effects* filter using a single spotlight. The magic comes when you enable the *Texture Channel* option. This uses an alpha channel as a bump map (see page 130) to add an impression of relief to the surface. Select the channel to use from the pop-up menu. We use the *Green* channel here. Once applied, the flat wall texture is transformed into an illuminated wall with 3D-style bricks.

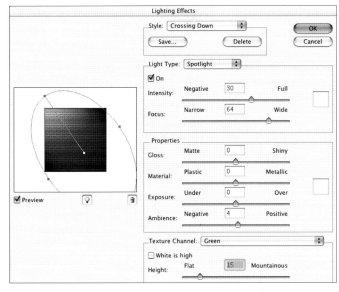

TEXTURES AND SHADING

Giving a 2D object a new texture is one thing, but if the object lacks the correct highlights and shading, then the effect isn't going to convince anyone. This is particularly true if you decide to replace one texture with another. Wooden surfaces, for example, can look very effective, but you won't get a good result if you just add a flat wooden texture to your image. The trick is to use a flat image of wood, but then put back the shading to give the illusion of depth.

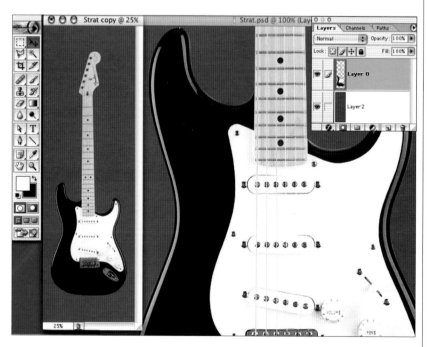

▲ **1** What we intend to do here is change the body of this guitar from plain black paint to a beautiful birdseye maple. Doing so is actually a lot easier than you might think, but it does require some painstaking masking. The first mask is the outline of the whole guitar, which we can draw using the *Pen* tool, before converting the outline to a selection and finally to a layer mask.

▲ **2** The maple layer is dragged in to the guitar document and scaled so that it fits over the whole body. By adding the guitar outline mask to the maple layer, we can remove the excess portion without tracing the outline again.

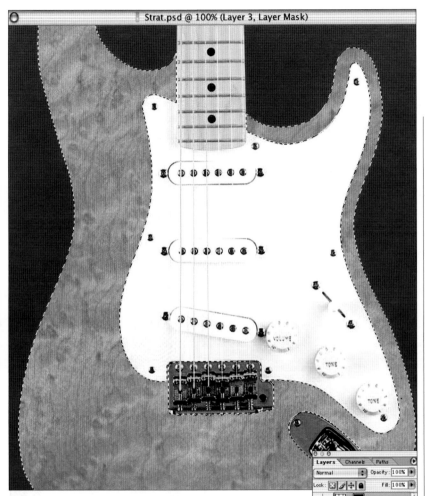

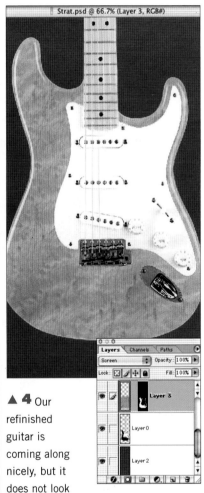

TIP *You can also 'wrap' wood textures around objects by using multiple layers transformed with the* Free Transform *tool. Your wrapping doesn't have to be perfect – in fact, you can get away with murder with this effect since the wood's texture can be quite random. Indeed, choosing more random wood grain images will work to your advantage in this respect.*

▲ **3** The next mask is more fiddly, and involves tracing around the bottom of the neck, the white scratch plate and the jackplug socket, again using the *Pen* tool. Load the path as a selection and fill it with black in the maple layer's mask. This will knock these portions out of the maple.

▲ **4** Our refinished guitar is coming along nicely, but it does not look very realistic because we have lost the reflections and highlights that were on the black body. Not a problem. By changing the maple layer's blend mode to *Screen*, the light portions of the paintwork show through the maple.

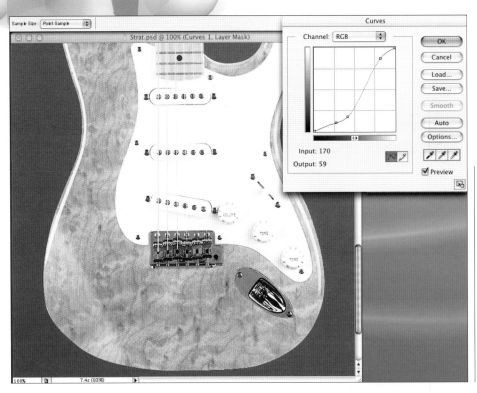

▼ 6 The guitar still looks a little flat, especially around the edges, but we can fix this with an *Inner Shadow* layer style. We cannot apply it directly to the maple layer because we would have too much of a shadow around the scratchplate. Luckily, there is a way around this. Firstly, we create a new layer, with the guitar outline loaded and filled with white.

▲ 5 A *Curves* adjustment layer is applied to increase the contrast in the maple's grain. In another layer, we add a small *Gradient* at the bottom left with the blend mode set to *Screen*. This makes a subtle reflection where the body of the guitar is chamfered.

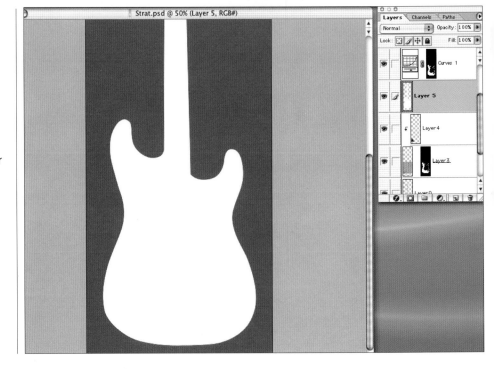

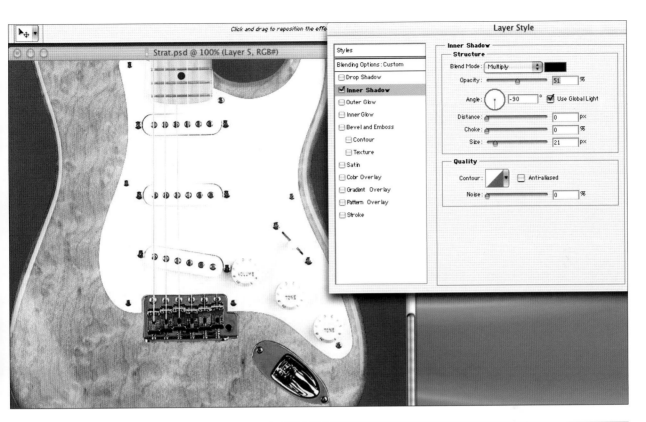

▲ ▶ 7 This new layer is applied using the *Multiply* blend mode so that it disappears. We now apply *Layer Styles* to this layer, so that enabling *Inner Shadow* will let the black shading be visible, multiplied over the layers below. This provides a subtle darkening of the rounded edges of the guitar body, putting back that vital 3D shading. The same trick is done with the scratchplate and hardware, but using a finer *Drop Shadow*.

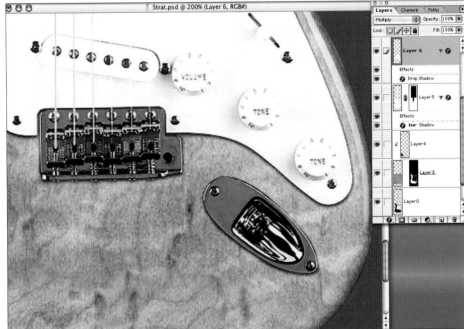

SIMULATING 3D IN 2D

In this chapter, we will show you how you can create convincing 3D objects without having to create 3D models, set up lighting, or render them in a proper 3D application. Thanks to the advanced features provided in the most recent versions of Photoshop, Photo-Paint, Paint Shop Pro and the rest, you can 'fake' sophisticated 3D images within 2D software.

We'll start off, however, with some basic projects. Spheres, charts and boxes are easy to produce, and creating fully textured and shaded 3D objects won't cause you any difficulties. From there we'll go on to show you some advanced 3D surfacing techniques using displacement mapping and other complex filters. By the end of the chapter, you'll have mastered transparency and reflections as well. Again, the projects use Photoshop and Illustrator for the sake of clarity, but the effects can be replicated – with a little thought and effort – using rival packages.

SIMPLE 3D SHAPES

Basic 3D shapes won't prove much of a challenge to a standard 2D application. In fact, simple 'primitives' – such as a sphere, cylinder or cube – can be created with relative ease. In this case we will use a vector application, Adobe Illustrator, to create the shapes. However, the techniques involved could be adapted for use in a bitmap application without much difficulty. Whatever program you use, this shaded 3D sphere can be created in a matter of minutes.

▲ 1 To create a ball, globe or any roughly spherical shape, you begin by drawing a circle. In most programs, holding the Shift key will constrain the circle so that it stays a circle and does not turn into an ellipse.

TIP *In a bitmap application, you can use gradient tools to create the shading. The only difference is that the gradient bitmaps are less editable afterwards. However, bitmaps offer more options for blending with the layers below – try using various blend modes for different effects.*

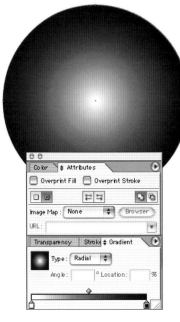

▲ 2 To create the highlight and shadow areas, use a *Gradient Fill*. In Illustrator, enable the *Gradient* option and change the *Type* from *Linear* to *Radial*. The default black-to-white gradient is applied with its centre located at the centre of the circle.

▲ 3 Switching to the *Gradient* tool allows us to move the centre point to the upper left, creating the illusion of illumination. The black is changed to a dark blue to give the ball some colour.

▲ **4** The default settings are fine, but we can edit the gradient for a bit more detail in the shading. Adding two extra 'nodes' in the gradient and changing their colours allows us to adjust the shape of the highlight region and the illumination fall-off. By adjusting the sliders in between each colour node in the gradient, we can also sharpen or soften the fall-off.

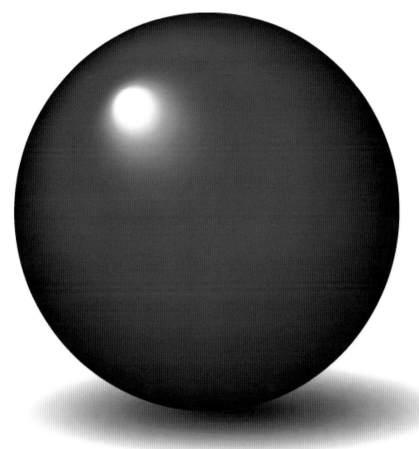

▲ **5** To add a drop shadow would send confusing signals, because this is supposed to be a 3D object rather than a floating, flat object. Instead, we need to simulate a shadow cast on to the floor beneath, taking perspective into account. Draw another circle, but this time with a white-to-black gradient.

▲ **6** Scale the new circle down vertically to make a flattened elliptical shape, as if the shadow was being cast on a floor plane beneath the sphere. It is important to scale the circle after the gradient is applied, or the gradient will not be scaled to give a convincing effect. The final trick is to send the shadow layer to the back of the document behind the sphere object. Scale and arrange the two until they look right on the page.

EXTRUDE WITH SHADING

You can also create a 3D object from any 2D object by extrusion. This doesn't work without effective shading, but there is a simple technique you can use to add this automatically. Well it's sort of automatic; it requires setting up, but as you perform the extrusion, the shading you've created is carried with it.

▲ **1** Here's our starting shape. It's a Wingding font applied as a text layer in Photoshop. This is a moderately complex object that will look good extruded and also demonstrate how easy it is to perform the technique.

▶ **2** The first step is to create a new layer and link it as a clipping group to the text layer. Option/Alt-click between the two layers to do this. Now the text layer is acting like a layer mask for the new layer.

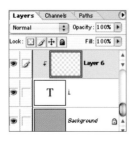

▲ **3** Next, choose foreground and background colours for your highlight and shadow areas. These will be the brightest and darkest shaded areas on the extrusion. Note that the dark colour is about 36% while the light colour is quite close to white with a 93% brightness value.

▲ **4** Note that each of the round sections will have the exact same shading. To do this, make a selection around the top 'blob' and use the *Gradient* tool to drag a gradient exactly across the full extent of the blob. Do it so that the highlight is in the direction you want the light to come. We've done it straight up and down for simplicity. You can do the other blobs in pairs because they are at the same position vertically. Note that it doesn't matter if you go over the spokes because we'll be dealing with these separately.

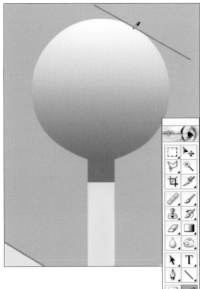

▲ **5** As the spokes are straight, each section will have the same shading. The surface points in the same direction, and it's their relation to the light source that determines their shading (we won't consider the effects of distance at the moment). To get the right shading, you just need to pick a matching colour from the gradient. Use the *Eye Dropper* tool for this and imagine a line tangential to the edge of the blob that should match the edge of the spoke.

▶ **6** The only parts that need to be precise are where an angle is going to appear in the extruded section. For that, the join must be as neat and sharp as possible – you can use a hard brush for this, though a selection is more precise.

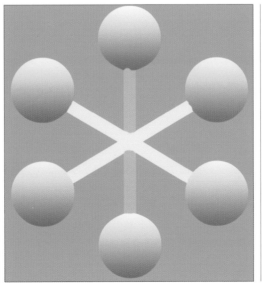

▲ **7** Finally, load the text layer as a selection. Choose *Selection>Modify>**Border*** and enter 4 pixels as the *Size*. Merge the gradients and spokes layers (if you made two) into one and then, keeping the selection active and the *Move* tool selected (this is important), press the arrow keys while holding the Option/Alt key (also important). For a 45° up/right extrusion, hit Up Arrow, Right Arrow in turn, repeatedly, and watch the extrusion grow!

WORKING IN PERSPECTIVE

In the introduction, we discussed how it is possible to create accurate perspective drawings using the techniques of one and two-point perspective developed by painters in the Renaissance. Of course, these techniques are directly transferable to the computer, so we will look at how we can use this technique to create an image using a standard bitmap editor, Photoshop.

▲ 1 Firstly, create a new RGB document 1400 pixels wide by 1200 pixels high. Before setting up the guides, it helps to change the *Ruler* settings to display units in percentage of the document size rather than cm, points or other units. This is done in the *Preferences* panel.

▶ 2 Typing Command/Ctrl-R displays the *Rulers*. Now you can click in the rulers to pull out guide lines. First a horizontal line is added at the 55% mark (holding the Shift key snaps the guide to the unit increments of the *Ruler*). This is the horizon line.

▶ 3 If you zoom out, you can place guides outside the canvas area. The vanishing points are marked by placing a vertical guide line at the -20% and 120% marks while a central guide is placed at the 50% mark. Two more horizontal lines are added to define the extreme top and bottom of the objects we will draw. These are arbitrarily chosen at the 40% and 80% marks.

▲ **4** Add green guide lines using the *Shape* tool, and place them in a layer folder so they can be easily turned off and on. Four lines are drawn, passing between the vanishing points and the intersection of the 50% guide and the two upper and lower extent guides.

▼ **5** Add more vertical guides to mark out the edges of the blocks we will draw. The positions are 18%, 30%, 35%, 65%, 70% and 82%. As you add the lines, you can see the basic forms taking shape.

▲ **6** Now it's a matter of joining the dots using the *Lasso* selection tool. First select one side and fill it with black in a new layer, then the other. It doesn't matter that they are black – it could be any colour – but this is the shadow side, so it needs to be darker than the highlight side, which is filled with grey.

▲ **7** Two more horizontal guides are dragged on the canvas to mark the top and bottoms of the block corners. Four more sets of guide lines are drawn in red here, to mark their edges. These are selected and filled again using the *Polygonal Lasso* tool, with each placed on layers behind the previous two.

BUILDING IN PERSPECTIVE

Creating product box shots gives us another good example of how we can create 3D objects with perspective. In this example, we will create a software box, giving it some shading and a shadow, but we will use a different method from making and filling in selections. The key to this technique is the Transformation tool. While available in Photoshop, it has equivalents in the other main bitmap-editing applications.

▶ **1** The great thing about this method is that it allows you to create the artwork for the box as a flat 2D image first, or to use an existing image such as the actual product artwork, for example. Here is the front artwork.

▼ **2** Together with the side panel artwork this image is gathered into a new document in which we will construct the 3D box. You could create some perspective guides as before, but with a simple object like this, and no other point of reference in the scene, your eye should be guide enough.

▶ **3** Single vertical and horizontal guides are added, allowing us to take the two pieces of artwork from their separate layers and snap them together. We also add a *Levels* adjustment layer above the background to darken it so that we can see the box edges better.

▲ **4** Using Photoshop's *Free Transform* tool, distort the front face as if it were viewed at an angle. Command/Ctrl-drag the corner handles until the effect looks correct. Keep the vertical edges parallel but angle the horizontal ones.

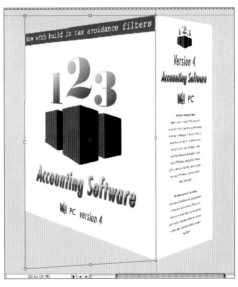

▲ **5** Now transform the side panel. Again, you need to keep the vertical edges parallel. After you have done this, you may feel that you need to re-adjust the other side in order to see the whole box in 3D.

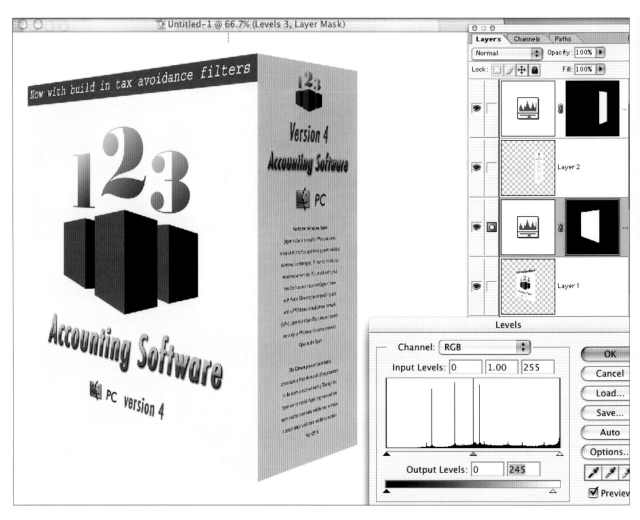

TIP *This trick can be used as an aid to visualising product packaging. The useful thing is that you can use the actual packaging artwork for the task in any stage of its design. Simply copy and paste it to a new document and make the transformation there.*

▲ 6 We want the box to sit over a plain white backdrop, so have turned off the background adjustment layer. To add shading to the side panel, we load its outline as a selection by Command/Ctrl-clicking the layer, and then adding a *Levels* adjustment layer. A layer mask is automatically created in Photoshop. Now move the white output slider to the left to darken the side, then repeat this step on the front to make it slightly darker than the background.

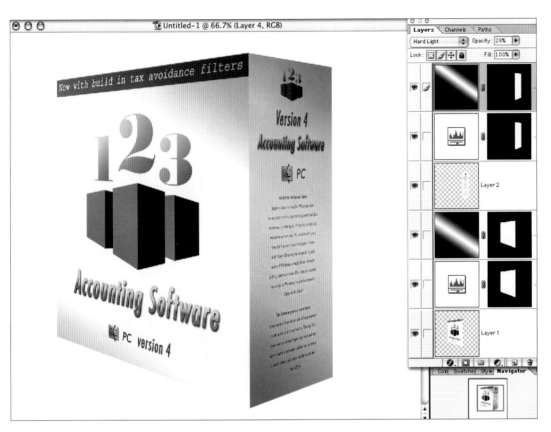

▲ **7** Add another layer with the same layer masks for the front panel, then draw a *Gradient* in *Reflected* mode diagonally over the box. Set the blend mode of the layer to *Hard Light*. We repeat the process for the side to add some extra shading to the box.

▶ **8** To finish our box, link all the layers and then use *Free Transform* to taper the box in at the base. This corrects the perspective distortion that we left in earlier by keeping the vertical edges straight. Finally, add a perpendicular shadow to situate the box on the floor.

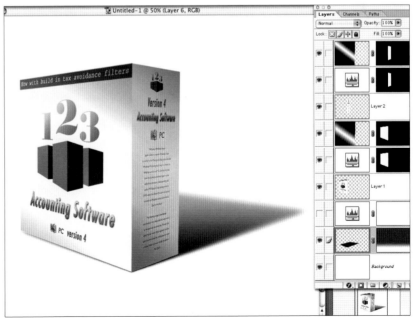

CHARTS

Charts, diagrams and graphs are graphic devices used to communicate fairly precise and complex information quickly and easily. Creating such diagrams in 3D need not be as difficult as you might think, but it is fairly involved. The trickiest part is working out in advance just how you are to accomplish the effect. A pie chart is a prime example. We can create one in 3D with segments that are stepped to add even greater impact to the results.

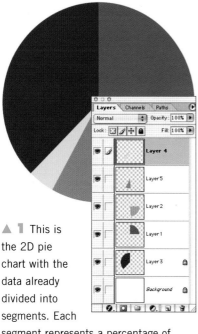

▲ **1** This is the 2D pie chart with the data already divided into segments. Each segment represents a percentage of some quantity or value, and pie charts are generally arranged so that segments change size in one direction around the chart. Here, each is placed on its own layer in Photoshop and given a colour.

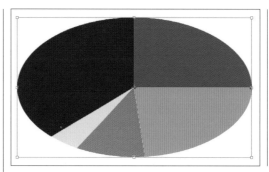

▲ **2** Link the segments to each other and scale them vertically, as if we're looking at the top of the chart at an angle. Don't worry about perspective correction. In this example it is not necessary.

▼ **3** We leave the green segment alone, but move the others up or down vertically by nudging with the arrow keys, to offset them. Try to get the gap between each segment roughly commensurate with the difference in size.

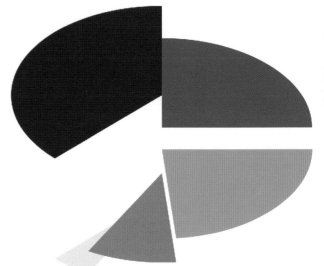

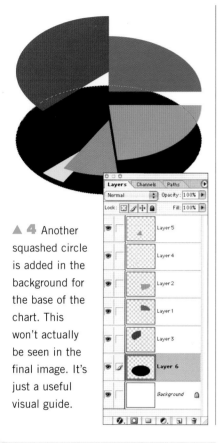

▲ **4** Another squashed circle is added in the background for the base of the chart. This won't actually be seen in the final image. It's just a useful visual guide.

TIP *A simple bar graph would be much easier to produce. Just use a modified version of the shaded extrusion trick on pages 54-5. After creating the flat top of each block, extrude it (with shading) downwards. To speed the process, stop extruding when the lowest part of the top face no longer intersects the extruded section. Now you can make a single line horizontal selection across the whole extruded part and use* Free Transform *to drag it to any length you want. Copy this to the other blocks.*

▲ **5** Add some vertical guides to the document. You should position these at the edges of the chart and at any outer corner. To create the front face of the 3D chart, you just join up the corner points of the segments using the guide lines for reference. Cut straight across the curved edges.

▶ **6** Now all you need to do is subtract each of the segments from this selection. Command-Option-click (Ctrl-Alt-click) each segment's layer to remove it from the selection. Save it as a channel for safekeeping. You should have something like this.

▼ ▶ **7** Create a mask by combining the base circle with a large *Rectangular Marquee* and applying the result as a layer mask to the front face layer. Note, however, that the yellow segment is peeping out over the front face. Another layer mask fixes this.

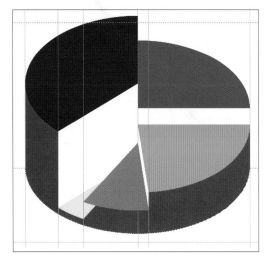

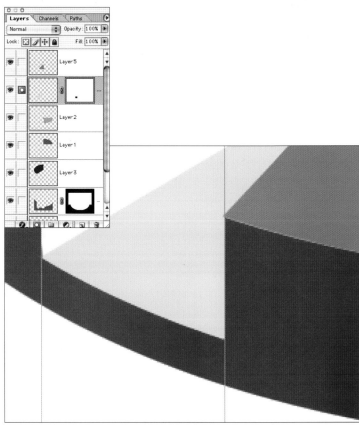

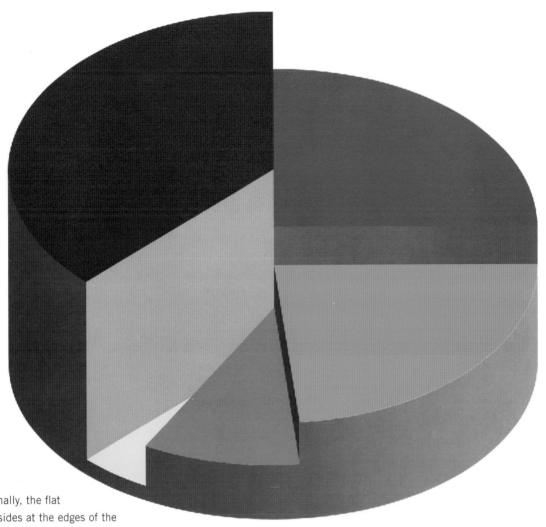

▲ **8** Finally, the flat vertical sides at the edges of the segments are filled in. These are oversized selections, which are placed below the front-face layer and the segments and initially filled with a flat colour. A *Gradient* layer is added above the front-face layer and linked to it to create a clipping group. This provides the shading and light direction for the chart. Each of the flat faces can then be coloured appropriately – filling them with their transparency locked – using sampled tones from the gradient.

▶ **9** Just because we can, we use *Free Transform* to add a little perspective distortion, then add a shadow to create the full 3D effect.

TEXTURED 3D OBJECTS

Making 3D objects is one thing, but giving them surface detail and texture is quite another. However, it is possible to distort simple flat artwork so that it fits around a 3D object. In this project, we will create a 3D cylinder from scratch and apply a texture to it. In this case, it's a can of a fictitious soft drink, and we are going to concentrate on wrapping a colour texture around the can. Adding bumps and reflection is a more complicated business, and one that we will deal with later on.

▲ **2** To build the can in our guides, we need to move the bottom horizontal ones so that they are wider apart, and then use the *Elliptical Marquee* tool to drag out two discs for the top and bottom of the can. Hold the Shift key to add the second disc to the selection.

GUIDES *You have two options when placing guides: you can either take perspective into account or not. As we are drawing the can from slightly above, the top and bottom of the can will be viewed at slightly different angles corresponding to their difference in height. In this example, we also take perspective into account – the bottom disc is slightly taller because we are looking at it slightly more face on than the top disc. The effect is subtle but sends the right visual cues.*

▲ **1** As with the earlier projects, you begin to create the can by setting up guides. The guides will be used to snap to when dragging out selections. For this example, we need to set up two vertical guides and four horizontal ones.

▲ **3** Switch to the *Rectangular Marquee* and Shift-drag a rectangle between the inner horizontal guides to fill in the body of the can. Fill this in with colour in a new layer.

▲ **4** Create the top cap of the can by making a new selection – slightly smaller than the can – in a new layer. Use more guide lines if necessary, but you can do it by eye. This creates a slight rim to the can. Fill the selection with a lighter colour.

▲ **5** Open the artwork you want to apply to the can body. Here is one that we created earlier in Photoshop. It is a mock-up of a cola can label, but it needs to cover only the portion that would be visible on the can.

▲ **6** Open a copy of the flat artwork and rotate it by 90° – we will explain why in a moment. Now apply the *Filter >Distort>***Shear** filter. However, this pushes some of the image off the edge of the canvas. To prevent this, we need to pop back to the original layered artwork and increase its *Canvas Size*.

▼ **7** Once the *Canvas Size* is increased and the layers tweaked to fill the space, another rotated copy can be sheared. The *Shear* filter allows you to bend artwork in one direction, which is why we rotated the artwork first. Clicking in the graph adds a point, and moving it bends the graph and thus the image. Using more than one point allows you to get a better shaped curve.

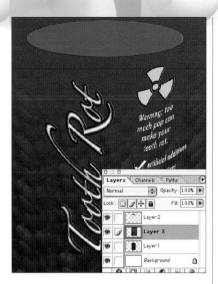

▲ **8** Once the *Shear* is complete, the image can be rotated again so that it returns to being the right way up. This image is now dragged from the *Layers* palette into the can document, resized to fit and placed below the cap layer.

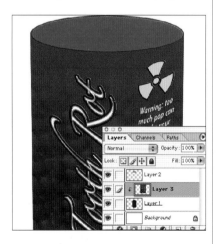

▲ **9** By Option/Alt-clicking on the dividing line between the label layer and the black can body layer, you can create a clipping group that uses the transparency of the can body as a mask. The label can easily be scaled and moved to fit the can.

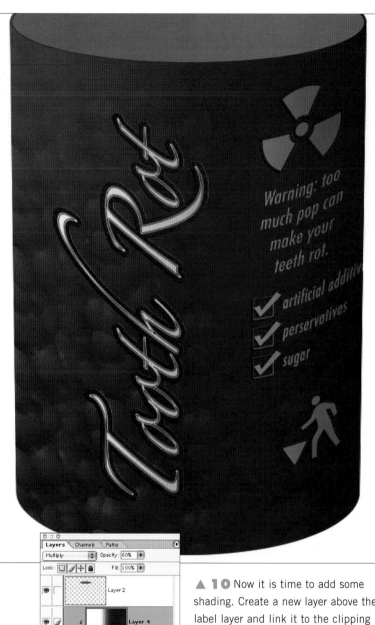

▲ **10** Now it is time to add some shading. Create a new layer above the label layer and link it to the clipping group (Option/Alt-click on its divider). Now draw a black-white *Gradient* in this layer, running horizontally across the can. If you change the layer's blend mode to *Multiply* and set the *Opacity* to approximately 40%, you will create a shadow area on one side of the can.

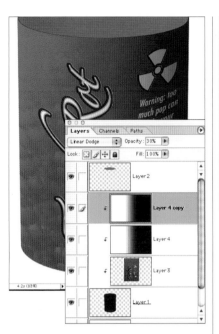

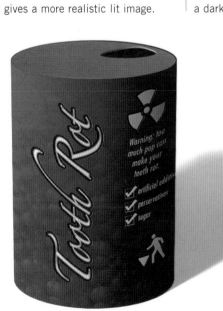

▲ **11** The lighter side could be left as it is, but to lighten it and heighten the 3D effect, duplicate the gradient layer with the second version set to the *Linear Dodge* blend mode. This takes only the white in the layer into account and gives a more realistic lit image.

▲ **12** To make the hole in the top, create a vector shape layer. You can make the hole with the *Circle Shape* tool, and then edit it to look more like the hole in a can of pop. Give the shape a dark grey colour.

▲ **13** Duplicate this layer and link the new layer as a clipping group to the original below. Change the colour of the duplicate hole to black and move it down to reveal a sliver of the grey layer below. This gives the top of the can the illusion of thickness.

◀ **14** Apply another gradient, again linked as a clipping group to the hole but in the reverse direction to the other two gradients. This adds some shading to the edge of the metal top. Finally, add a perpendicular shadow to complete the 3D textured can.

MIRROR REFLECTIONS

When you're simulating 3D objects in 2D, reflections add a lot of visual clout. However, creating them can be quite involved. Environmental reflections – those that you get on the surface of shiny objects – allow you to get away with using almost any image as a reflection, since the image is usually distorted. Mirror reflections are less forgiving. As they are not distorted, you can see exactly what is reflected. There are still easy ways of adding them, and to prove this we will create a very basic image of a table, then add the mirror reflection.

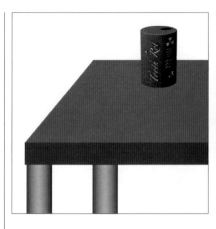

▲ **3** Here is the object that will be reflected in the table top. It's the can from our previous example, which we drag into the table document and scale using the *Free Transform* tool.

▲ **1** We begin by creating a simple 3D table from scratch. Of course, you could be working with a photograph to which you want to add reflections, because you are creating a realistic composite, for instance. In any case, the procedure for adding reflections is the same.

▼ **2** Here are the legs – just simple reflected gradients which have been adjusted with *Levels* to look like cylinders. How simple can you get?

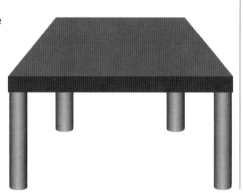

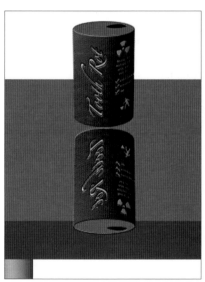

▲ **4** As you know, a mirror reflection is reversed. If we duplicate the can and flip it vertically using *Edit>Transform>* ***Flip Vertical***, we get a reversed image of it. However, when we move the reversed can into position below the original, it's clear things aren't right.

TIP In Step 8, we mask the reflection so that it doesn't extend beyond the table's surface. This can be very handy – for example, for creating web animations. Restricting the reflection to the boundary of the reflective object means that the reflection can move across the surface in a very believable way, especially when the edge of the object begins to clip the reflection. You could make use of this effect in, for example, a rollover for a website.

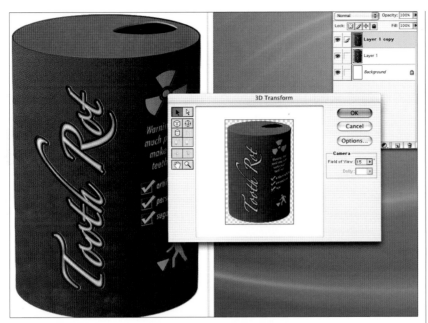

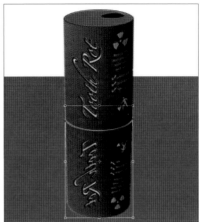

▲ **5** Creating a mirror reflection is not as simple as flipping the object. We also need to take into account the change in viewing angle. Enter Photoshop's *3D Transform* filter. Re-open the Can document, then create a duplicate layer and apply the filter by selecting *Filter >Render>**3D Transform***.

▲ **7** Drag the transformed can back into the table document and scale it to fit. Now flip it to create the mirror image. This time it looks correct.

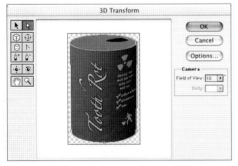

◀ **6** In this example, the object is a simple cylinder, so we drag out a cylinder and edit its handles using the arrow tool. To match the perspective in the image, line up the bottom edge, then adjust the *Field of View* slider until the top matches that in the image. Use the *Rotate* tool to rotate the can so that the top is hidden but the bottom is still visible.

▼ **8** By reducing the opacity of the reflection layer, and even adding a bit of *Ripple* filter to distort it slightly, we can suggest the surface qualities of the table top. Even in this simplest of simple images, the effect works wonders. In this example, we have duplicated the can and added a mask to restrict the reflection to the table top.

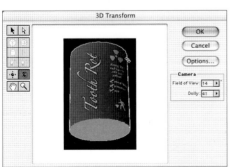

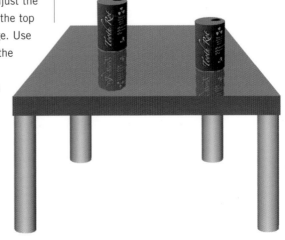

BUILDING 3D OBJECTS

We have seen how to create various kinds of objects in Photoshop and how to apply shading and other surface attributes. Now we'll create a more complex 3D object from scratch. In this case, we are creating an icon of a hard disc drive, similar to the one you would find in Apple's OS X operating system. The graphic could be used for any purpose – a magazine article, hardware manufacturer's website or promotional material – it's our approach to making it that counts.

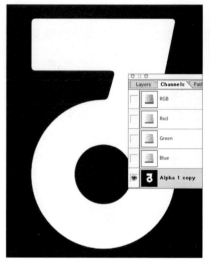

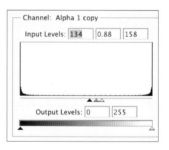

▲ **1** We begin by creating a rounded rectangle using the *Shape* tool. The *Shape* tool creates a vector mask applied to a special colour layer, so we can easily edit the masks and colour without risking any degradation of the original pixels.

▲ **2** We add the perspective straightaway. As it's a simple viewing angle, we will avoid the task of drawing vanishing lines and use this layer as a visual reference instead. The shape is altered using the *Free Transform* tool, then duplicated and offset vertically to create the top and base.

▲ **3** The pressed steel cover is next. First, open the *Channels* palette and create a new alpha channel. Use this to draw the shape of the indentation head-on. Now *Blur* the shape and adjust it with *Levels* to sharpen the sides up again. This gives us a combination of crisp edges with nicely rounded corners.

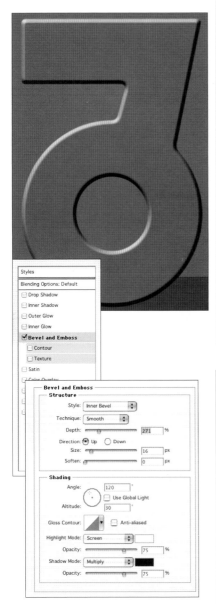

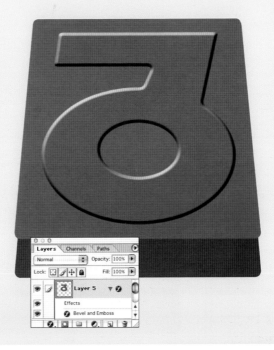

**BREAK
THE LINK**

*If in Step 5 you were
to go ahead and
Transform the layer
before unlinking the
layer styles, the result
would not be right.
Notice that the* Bevel
and Emboss *is not
distorted because the
effect is continuously
applied to the layer as
a 'live' effect. The
indentation looks
distorted as a result.*

▲ **4** Load the alpha channel as a
selection and fill it with 50% grey in a
new layer. It's now time to apply the
Bevel and Emboss layer style. This has
to be done before any further
transformation is applied to provide the
necessary 3D relief.

▶ **5** Convert the layer style
to layers *(Layer>Layer Style
>**Make Layers**)* and link them
together. This means that
when you transform the
indentation layer to match
the top and base, the
shading will also be
transformed. *Transform* the
layers, then unlink them and
offset them vertically, so that
the front facing edges have
more shading showing than
the backward facing edges
(since they are tilted away
from us). At this point, you
can also flip the illumination,
so that the front edges are
light and the back ones dark. This is
simply achieved by inverting the colours
in the bevel layers and swapping blend
modes from *Multiply* to *Screen*.

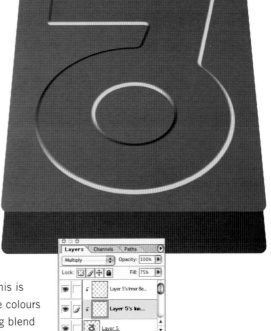

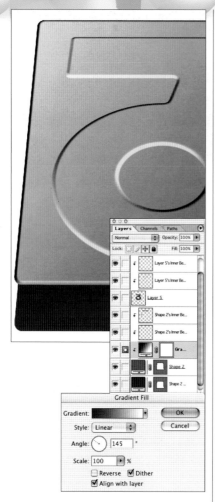

▲ **6** Add a *Gradient Fill* layer to give the top a metallic sheen, using a white-to-dark grey gradient at a 145° angle. This is grouped as a clipping group to the top-plate shape layer. The same bevel trick can be applied to the top-plate layer as in the previous step, offsetting the layers to hide more of the rearward edges. The blend mode of the indentation layer is set to *Overlay*, which makes it invisible since we filled it with 50% grey earlier on.

▲ **7** The next few steps are quite involved. What we want to do is give a more metallic look to this pressed steel top plate of the drive. This involves two processes. Firstly, we need to get a more metallic looking sheen to the flat and bevelled parts. More importantly, we must create micro-bevels at the edges of the bevels where they change direction. To break with tradition, we will show you the end result first. As the steel plate is bent to create the indentation for the drive mechanism, the steel does not produce a sharp edge – there is a very small rounding. This rounding catches the light and has a different shading from either the flat top or the bevel. Attention to detail is the key to 3D graphics, so we need a selection to isolate the area in question.

▲ **8** The highlight and shadow bevel layers (all four of them) are loaded as a selection and saved as an alpha channel. The top plate shape is then loaded as a selection, inverted and used to trim away the excess.

DETAILS *Whether you're modelling objects in a 3D application or building them in a 2D image-editor, attention to detail is everything. The micro-bevels in the corners (shown here) are a perfect example. Recreating them adds an extra touch of solidity to the result.*

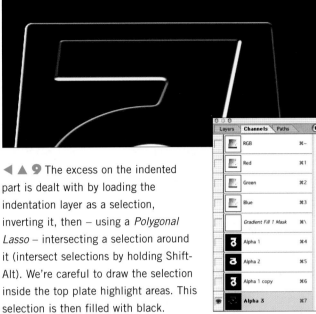

◄▲9 The excess on the indented part is dealt with by loading the indentation layer as a selection, inverting it, then – using a *Polygonal Lasso* – intersecting a selection around it (intersect selections by holding Shift-Alt). We're careful to draw the selection inside the top plate highlight areas. This selection is then filled with black.

◄10 Using this alpha channel as a mask, a *Gradient Map* layer is added at the top of the layer stack. This allows us to remap the tones in the bevel areas to provide the tiny micro-bevels on the metal case. Note that where the bevel is dark, it is flanked by two light edges, and vice versa.

►11 The overall lightness of this new shading is controlled by adding a *Levels* adjustment layer again, using the bevel mask we have created. The *Gradient Map* that we are using to shade the top plate is also adjusted to give a better overall sheen.

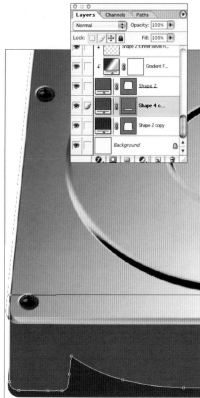

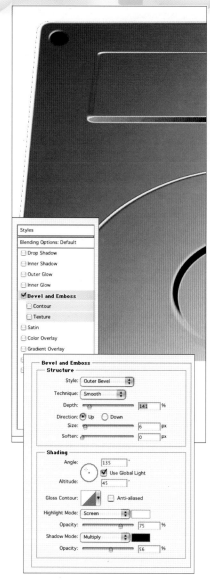

▲ **13** The holes are filled with screw heads. There is no magic technique here: these are created by hand using selections, the *Dodge* tool (to add shading) and *Levels*. Duplicate the screw five times to fit each hole.

▶ **14** The cast body of the drive seen at the front is created next. A layer of solid colour is added between the top and bottom plate layers, then a vector mask is drawn to mark out its shape. With no perspective drawn in, the vertical edges don't taper realistically, but we can add this distortion later on.

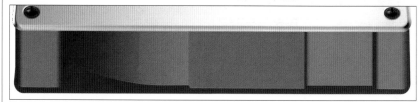

▲ **12** We now create the screw holes using a *Vector Shape* layer. First, an elliptical vector shape is created and then, using the *Path Select* tool, this shape is duplicated five times (by dragging while holding the Option/Alt key) to make the six screw holes. Use an *Outer Bevel* layer style to produce the indentations.

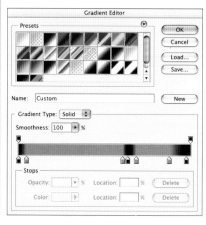

▲ ◀ **15** Add a *Gradient* layer above the solid colour layer and group it to it. Use this to create the shading of the cast body of the drive. Rather than do it all in one gradient – which would be difficult – three are used. Each one has a layer mask that confines it to one section of the body. The *Align to Layer* option in the *Gradient* options confines the gradient to the area in the mask. Set the blend mode of each layer to *Hard Light* and adjust the *Opacity* to fit.

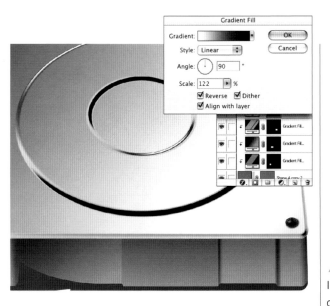

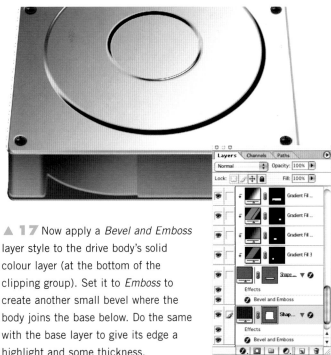

▲ **16** Add a fourth *Gradient* layer, with the blend mode set to *Soft Light*, and link it to the previous clipping group. This is used to add a subtle vertical shading to the drive body.

▲ **17** Now apply a *Bevel and Emboss* layer style to the drive body's solid colour layer (at the bottom of the clipping group). Set it to *Emboss* to create another small bevel where the body joins the base below. Do the same with the base layer to give its edge a highlight and some thickness.

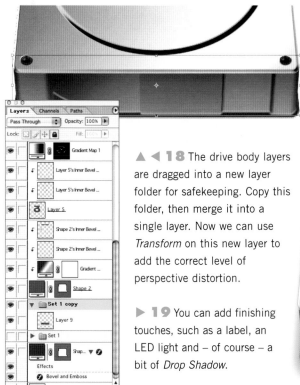

▲ ◄ **18** The drive body layers are dragged into a new layer folder for safekeeping. Copy this folder, then merge it into a single layer. Now we can use *Transform* on this new layer to add the correct level of perspective distortion.

▶ **19** You can add finishing touches, such as a label, an LED light and – of course – a bit of *Drop Shadow*.

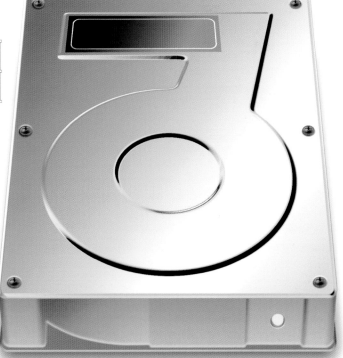

VECTOR 'GEL' BUTTONS

After such a complex project, let's do something simple. 3D buttons, windows and menus are increasingly popular in applications and operating systems, and on websites. The gel-like translucent buttons and tabs popularized by Apple's OS X operating system are good examples. The gel button doesn't just have the usual 3D feel: it appears to be made from a translucent material that looks soft and high-tech at the same time. You can easily create the 3D effect in a vector illustration program. Vectors allow you to repurpose the button at many different sizes – even for use in print – without incurring a loss of quality.

▲ **1** The tool of choice in this example is Adobe's Illustrator, though Deneba Canvas or Macromedia Freehand are worthy alternatives. We begin by creating the button outline – a simple rounded rectangle.

▲ **2** Fill this shape with a very dark blue colour using the *RGB Colour Picker.* Set the outline to *None.* Duplicate this object by dragging it to the *New Layer* icon in the *Layers* palette. You need to make two copies.

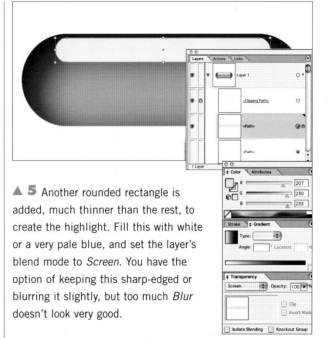

▲ **3** Convert the layer group into a clipping group, whereby the topmost sub-layer clips away all the layers below it at any point where their contents extend past its boundary. The second layer is than moved down slightly and scaled smaller, with its fill colour changed to a pale blue.

▲ **5** Another rounded rectangle is added, much thinner than the rest, to create the highlight. Fill this with white or a very pale blue, and set the layer's blend mode to *Screen*. You have the option of keeping this sharp-edged or blurring it slightly, but too much *Blur* doesn't look very good.

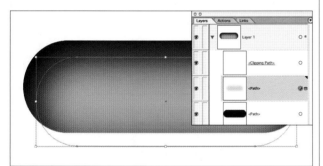

▲ **4** We create the main, translucent glow of the button by applying a *Gaussian Blur* filter to the pale blue layer, then adjusting its transparency. Because of the clipping group, the glow is visible only inside the button. You may also need to adjust the colour of the fill at this point – in this example, we have made it more saturated.

▲ **6** Finally, create some extra colour depth by duplicating the translucent glow layer and changing the fill to a deeper saturated blue. Move this upwards to lie across the top of the button. A drop shadow is added in a new layer group below, so that it's not part of the clipping group. With the colour set to a dark blue and a heavy blur, it looks as if the light is tinted by the button's gel material.

VECTOR SHADING

Web buttons are one thing, but when it comes to creating more complicated 3D shapes in a vector-based drawing application, things get tricky. The difficult part is applying the shading to the sides of the object, especially if the object has curved edges. The answer is to use gradients to add light and shadow to the 3D object. To do so effectively, we need to split up the shaded areas, where possible, so that the gradient follows the contours of the object.

▲ 1 Here is the artwork that we want to turn into a 3D object. It's a simple enough shape, but notice that there are no sharp edges. There's a reason for their absence: they would make it difficult to define start and end points for the gradients we use in shading.

▲ 2 The first step is to duplicate the outline and offset it to create some depth. We have also filled the top arrow with white to obscure the arrow behind. This gives a better idea of how the final object will look.

▲ 3 Selecting the rearmost arrow, proceed to select the few points that make up the arrowhead. These are copied and pasted to a new layer. They actually end up as two different segments, so you should join these into a single path.

▲ **4** Edit the path to form the side of the arrowhead extrusion. Place the layer below the main arrow layer and add a few extra points to close the path so that it can be filled.

▲ **5** Having joined and closed the path, we now have to split it in two again. We do so to give us more control over the gradient shading, especially across the rounded tip of the arrow head. The *Scissors* tool is used to cut the path into two separate entities, kept flush right through the tip. We have filled one with black so that you can see how it's done.

▲ **6** Using the *Gradient* tool, drag out the gradient perpendicularly to the edge we have just cut. Do so in both halves. By editing the gradients, you can create a smooth transition across the tip and adjust the shading of each side independently. The point where they join is matched by making sure that the grey colour swatch for each has the same value.

▲ **7** The shading for the rest of the arrow is created in a similar way, except in this case we don't need to split the path – we just use a more complex gradient to define the shading areas.

▼ **8** Finally, apply a drop shadow by blurring a black-filled copy of the main arrow path. The outlines for the arrow could be left on if you like, for a more illustrated look. Here, we have filled the front face with a pattern.

DISPLACEMENT EXPLAINED

Having created some complex 3D objects, we're ready to look at some of the most advanced 3D techniques that Photoshop allows. The first, displacement mapping, is a powerful addition to any digital artist's repertoire. In basic terms, a displacement map is a bitmap image whose channel brightness values are used to displace pixels in another image. You can use displacement maps in many ways – for instance, to wrap some text over a crumpled T-shirt or create refraction effects through glass.

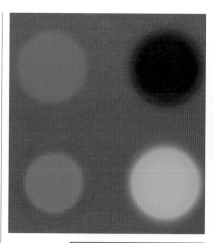

▲ **1** The best way to show you what displacement mapping does is by example. Here is the image we are going to use displacement mapping on...

▲ **2** ...and here is the image that will be used as the displacement map.

▲ **3** Here is the final result. You can see that the clouds image has caused a random-looking disturbance of the grid image, with the lines moving to reflect the effects of displacement.

▲ **4** OK, let us now look more closely at what is going on. Photoshop looks at the first two channels of the displacement map – red and green in an RGB image – and uses these to displace pixels in different directions. Here is a demonstration: the image uses a 50% grey background (50% grey produces no movement since it is the mid-point) but has black and white coloured spots in the red and green channels. The colours are meaningless: what is important is that there are black and white spots in different locations within the two channels. The blue channel is simply ignored by the filter.

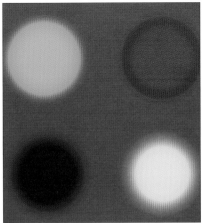

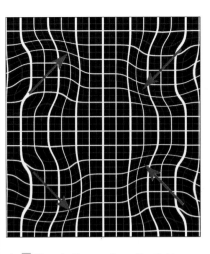

▲ **5** Here is the result of applying this displacement map to the grid image (note that the displacement is more controlled). The green channel (Channel 2) moves pixels only up or down, the red channel (Channel 1) moves pixels only left or right. This is a breakdown of what happens:

In Channel 1, the black pixels displace the pixels in the layer above to the right, while the white pixels displace them to the left. In Channel 2, the black pixels displace the pixels in the layer above in a downward direction, while the white pixels push them upwards. In both channels, 50% grey is neutral, causing no displacement. All other channels are ignored.

▲ **6** With that information, can you figure out what will happen using this image as a displacement map? Note that if black and white overlap in the two channels, they don't cancel each other out!

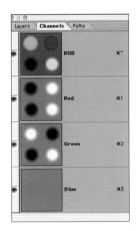

▲ **7** Here is the result on the Grid, clockwise from top left:
Channel 1 = Black, Channel 2 = White: displacement up and to the right;
Channel 1 = White, Channel 2 = Black: displacement down and to the left;
Channel 1 = White, Channel 2 = White: displacement up and to the left;
Channel 1 = Black, Channel 2 = Black: displacement down and to the right.

▼ **8** To apply a displacement map use *Filter>Distort>**Displace***. The dialog enables you to choose the amount of displacement (where 100% equals a maximum of 128 pixels). If the two images are different sizes, you can make the displacement map scale to fit or tile across the destination image. You can also make pixels that are pushed off one edge, wrap back around on the opposite side, or fill edge gaps with whatever colour was there before.

SAVED *You can't save a displacement map in just any file format. The best one to use is the Photoshop 2.0 format. The standard Photoshop format will not work.*

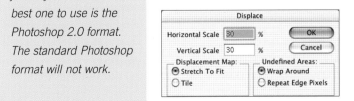

USING DISPLACEMENT

Displacement mapping can be used for all kinds of 3D tricks. One way to use it is for wrapping textures around 3D shapes, or making it look as if a 3D object is distorting a 2D surface. In this example, we will use it in combination with a 3D render to create the effect of a face pushing against a stretched-out piece of fabric. This can be done in 3D as well, but can be quite involved – it's far easier to do some things in a 2D program.

▲ **2** When we render the image, this is what we get. The distances between parts of the model and the camera are represented by shades of grey, which is just what we need to create a useful displacement map in Photoshop.

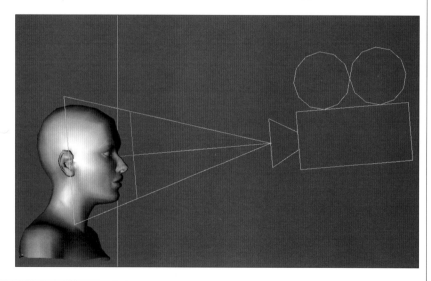

TIP You can create the effect of fabric stretching where the 3D object pushes against it by painting over the displacement map. Use a new layer and paint with a grey colour sampled from the edge of the face. Paint radial streaks around the face and set the blend mode to Lighten mode, blurring the result if necessary.

▲ **1** Here is the 3D model we want to use. In order to get a displacement map, we must render the depth information in the scene. A camera is set up with the depth region settings required. In this case, the tip of the nose will be white and the side of the head black. Some 3D applications, such as Bryce, will set the depth map range for you automatically.

▲ **3** Save the render in a suitable format, then open it up in Photoshop. The next step is to apply a *Gaussian Blur,* which softens the hard edges in the depth map, particularly the outline. This allows a smoother transition from the undisplaced to the displaced region – in the way that cloth tends to behave. Save the result in Photoshop 2 format.

▲ **4** Next, open an image to displace. This image has a familiar pattern, but more important is the weavelike texture, which will help to show up the displacement. Large areas of solid colours don't tend to work too well when displaced – you need edge detail.

▼ **5** The texture is cropped so that it has the same proportions as the displacement map – you could also work the other way and make the displacement map the same aspect ratio as the texture by padding or cropping it appropriately. Run *Filter>Distort>**Displace*** and enter 50 x 50 as the displacement value, with *Stretch To Fit* and *Wrap Around* as the apply options. The result is a facelike impression in the texture.

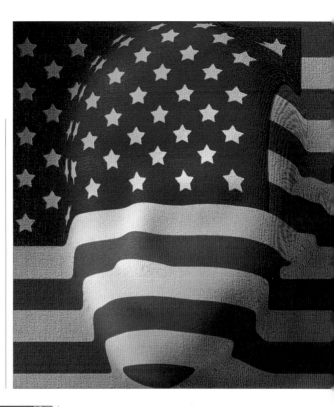

▲ **6** You can improve the shading of the end result by using the *Dodge* and *Burn* tools, adding shadows and highlights appropriately. Alternatively, try using the displacement map as a layer with the blend mode set to *Overlay* to add some shading to the face.

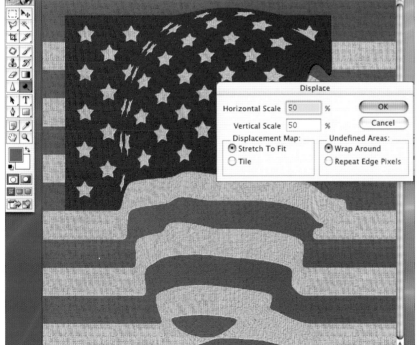

COMPLEX DISPLACEMENT

The Displace filter can also be useful when you want distortion to follow a precise pattern; there's really no other way to do this in Photoshop. In this example, we'll use the Displace filter to create a pseudo-3D glass icon. One of the main properties of glass – or any other transparent material – is the ability to refract light. Objects seen through the transparent object appear distorted, and it's this bending of light that we can simulate using the Displace filter in combination with Photoshop's Layer Styles effects.

▲ **1** Here is our background image. It doesn't really matter what the background is in order to demonstrate this technique, but it works best with images that have plenty of detail in them. Flat colours or subtle gradients don't usually work so effectively, as there is too little information in them for the *Displace* filter to work on.

▲ **2** The glass object begins life as a type object on a new layer, which is rendered and encircled with a thick border. This could be an imported EPS logo or a design created from scratch. Like the background, the object has to have some detail in its shape for the effect to work properly. Shapes that are too simple or too complex don't tend to work as well. Deciding whether to go the displacement map route at all will depend greatly on these factors.

▲ **3** Duplicate the whole document using *Image>**Duplicate***, and fill the background with 50% grey. 50% grey is the neutral colour in a displacement map, and won't cause any movement. Save the logo as an alpha channel for safekeeping, then flatten the image so that you can modify the channels independently. In two-channel displacement maps (see pp 82–3) the first two alpha channels (red and green in an RGB image) move pixels in opposite diagonal directions.

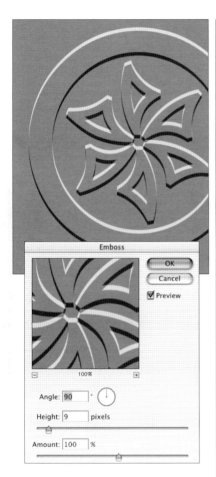

▲ **5** To soften the effect of the *Emboss* filter, select the RGB channel and apply a *Gaussian Blur*. The blurring and embossing has spread the icon past its original outline so now we need to eradicate the overspill. Load the saved alpha channel of the unblurred icon as a selection and use it to fill the background with 50% grey.

▲ **6** As before, this file must be saved as a Photoshop 2 PSD file. All of the alpha channels are saved in the file, but when read by the *Displace* filter, only the first two are taken into account.

▲ **4** We can use this fact to create a realistic glass distortion. With the newly flattened image, open the *Channels* palette, select the *Red* channel and run the *Emboss* filter, with the *Amount* set to 100%, a *Height* of 9 and an *Angle* of 180°. Run the filter again on the *Green* channel, but with an *Angle* of 90°.

▶ **7** Back in the original document, select the background layer and apply the *Filter>**Displace*** filter. Set the desired amount of displacement in the *Horizontal Scale* and *Vertical Scale* to around 25% each. 100% represents a maximum of 128 pixels displacement, so the resulting effect is quite subtle when there are no other visual cues in place. We'll add those next.

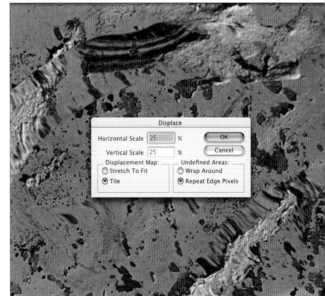

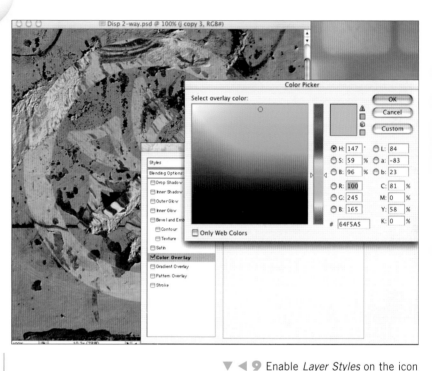

▶ **8** The first step is to fill the icon with 50% grey. To do this, enable the *Protect Transparency* option for the icon layer, by clicking the small chequered icon at the top of the *Layers* palette. This means that the icon can be filled with a colour without filling the whole layer. Set the layer's blend mode to *Overlay*, which effectively makes its base colour – the 50% grey – invisible. The actual colour of the glass – in this case, a pale green – is created using the *Color Overlay* option in *Layer Styles*. The benefit of this is that the layer style can be saved as a preset style for reuse, so the colour of the glass remains in the preset, not the bitmap layer.

▼ ◀ **9** Enable *Layer Styles* on the icon layer to create the glass surface. First, activate *Bevel and Emboss* and set the style to *Inner Bevel*. To get the glassy highlight, set the Global light angle to nearly overhead (*Angle:* -135°, *Altitude:* 84°). The other settings are: *Depth:* 41; *Size:* 13; *Soften:* 1; *Highlight mode: Screen, Opacity* 86%; *Shadow mode: Color Dodge, Opacity:*100%.

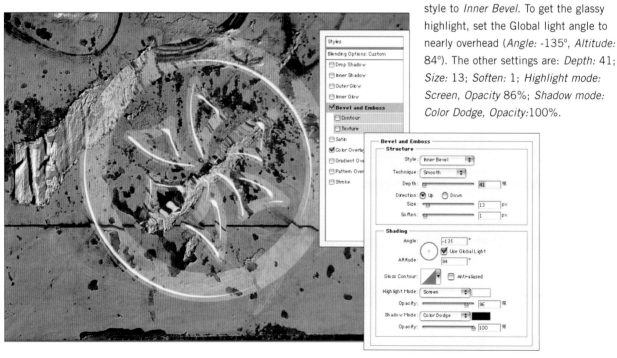

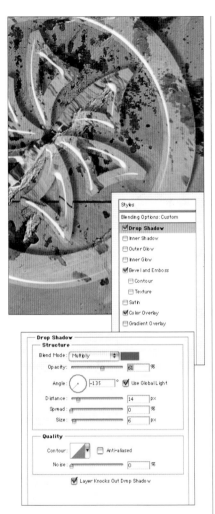

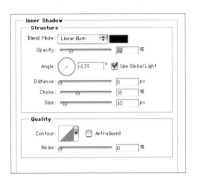

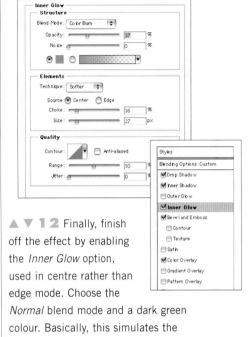

▲ **11** The Fresnel effect (see p 100) is simulated by darkening the edges of the glass using the *Inner Shadow* option. This has the effect of making the glass more realistic but also helping to delineate its form.

▲▼ **12** Finally, finish off the effect by enabling the *Inner Glow* option, used in centre rather than edge mode. Choose the *Normal* blend mode and a dark green colour. Basically, this simulates the accumulation of colour in the areas where the glass is thickest. It's a subtle change, but worth it.

▲ **10** Add a *Drop Shadow*; note that the glass is transparent and the shadow needs to reflect this. Set the shadow colour to a similar but darker green. Use the *Multiply* blend mode, but with a lower 61% *Opacity*.

WIREFRAME 3D SPHERE

Another advanced filter comes into play in this next project, namely Polar Coordinates. We're going to use it to create a pseudo-wireframe overlay, which will partially cover an image of the earth. This technique is really only capable of creating wireframe hemispheres rather then whole spheres, but it does create the concentric-rings kind of wireframe that you would expect from a proper 3D program.

▲ **1** We start off with our Earth image, the idea being to overlay a wireframe over its top half. To do this using a 3D program is relatively easy, though getting a decent quality wireframe at high-resolution can be quite tricky.

▲ **2** However, we can create the wireframe effect within Photoshop, which gives us more control over things like the thickness of the lines and the number of divisions. To begin, create a new document 128 pixels high by 64 pixels wide and filled with black.

▲ **3** The reason for the dimensions will be apparent in a moment. *Select>All*, then use the arrow keys (with the *Marquee* tool selected) to nudge the selection up and left (or down and right, etc) the number of pixels you want the lines' width to be. We've gone for 5 pixels here.

▲ ▶ **4** Invert the selection (Command/Ctrl-Shift-i) and fill it with white. If white is the background colour, you can fill by typing Command/Ctrl-Delete. We *Select>**All*** again, then choose *Edit >**Define Pattern*** to save the selected area into the pattern library.

◀ **5** Now create a new document, 1024 x 1024 pixels in size. As this is divisible by 128 and 64 (see Step 2) the pattern will tile evenly. We create the grid by choosing *Fill...*, setting it to *Pattern* mode and using the new pattern that we created in Steps 1 through 4.

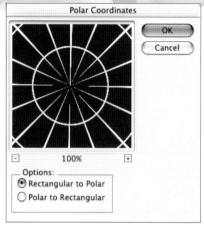

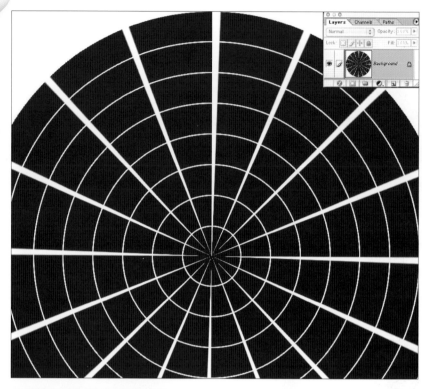

▲ ▶ **6** Apply the *Distort>**Polar Coordinates*** filter to the grid using the *Rectangular to Polar* option. This wraps the image around a sphere, compressing one whole side to a point in the centre to make a radial array of lines. If the grid was regular (e.g. 64 x 64 pixels), there would be too few radial lines.

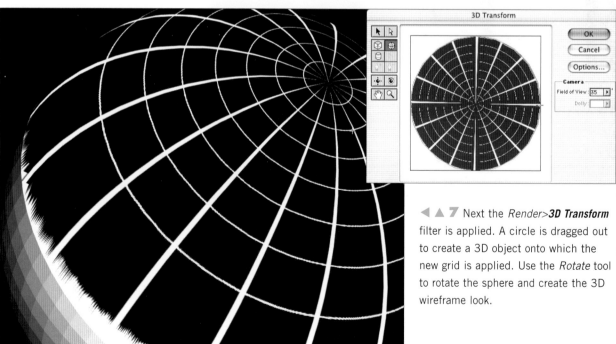

◀ ▲ **7** Next the *Render>**3D Transform*** filter is applied. A circle is dragged out to create a 3D object onto which the new grid is applied. Use the *Rotate* tool to rotate the sphere and create the 3D wireframe look.

TIP Polar Coordinates *can be used for many other 3D effects. When creating texture maps for use in a 3D program, specifically spherical environment reflection maps, you can use* Polar Coordinates *to pre-distort the image map in Photoshop, painting out the distortion that can occur at the poles.*

▼ **8** The wireframe layer is dragged on to the Earth document and scaled to fit. Set the blend mode to *Screen* and the black disappears. Finally, use a circular *Gradient* layer mask to fade the edges.

BUILD YOUR OWN WORLD

The preceding tutorial showed you how to wrap a wireframe grid partially around a sphere (and the same would work for any other texture). In that case, the object was an image of the Earth – an image which, hard as it might sound, is quite possible to create in a bitmap-editing application such as Photoshop. To do this, you will have to add 3D shading, surface texture and distortion. We also need to take into account the visual effects of the planet's atmosphere.

▼ **2** Add a *Gradient Map* adjustment layer. This remaps the greyscale tones in the layers below it to the gradient that you specify. To create our world, we design a custom gradient that will represent the desert, fertile land, shore and sea areas of the planet using browns, greens and blues. Of course, these colours could be changed to make any planet of your choosing. If you want lime-green seas and pink mountain peaks, go ahead.

▲ **1** To create any kind of alien planet that has continents and seas, we can begin by applying the *Clouds* filter (*Render>Clouds*) to the background. Photoshop's *Clouds* is a kind of fractal generator that produces random results.

▲ **3** Apply *Levels* to the clouds layer to create distinct land and sea areas. Rather than apply *Levels* directly, try using an adjustment layer. That way, you can reapply the *Clouds* filter until you get the type of terrain you want.

▲ **4** Using Photoshop's star-shaped brushes with a low opacity, paint on the clouds layer. Because of the interaction of the *Levels* and *Gradient Map* adjustment layers, you can etch into the landscape to create the bays, rivers, lakes and fjords of your world.

▼ **5** Once you are done with your planet surface, you can save a flattened version or flatten the document to a single layer. Here we have also added a polar ice cap.

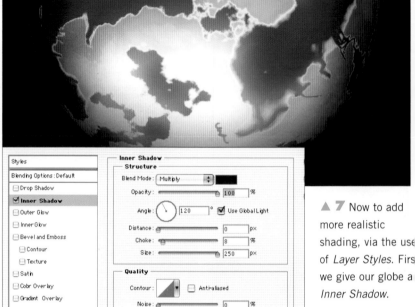

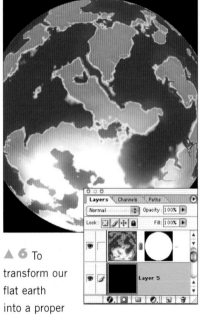

▲ **6** To transform our flat earth into a proper globe, we simply need to use the *Spherize* filter (*Filters>Distort>**Spherize***) at 100% strength. We will need a circular mask, however, to knock out the undistorted areas with the background filled with black.

▲ **7** Now to add more realistic shading, via the use of *Layer Styles*. First we give our globe a *Inner Shadow*.

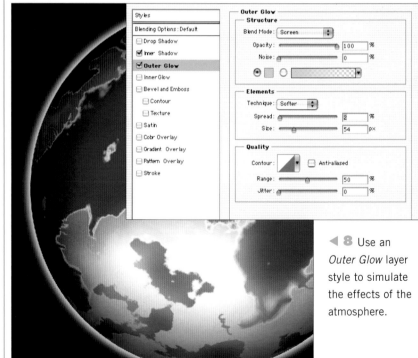

◀ **8** Use an *Outer Glow* layer style to simulate the effects of the atmosphere.

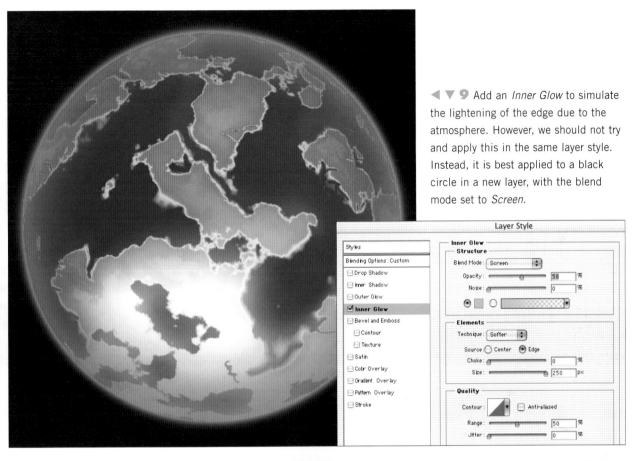

◀ ▼ **9** Add an *Inner Glow* to simulate the lightening of the edge due to the atmosphere. However, we should not try and apply this in the same layer style. Instead, it is best applied to a black circle in a new layer, with the blend mode set to *Screen*.

▶ **10** A shadow and highlight finish off the effect. The highlight has been masked so it affects only the water, which is, of course, more reflective than the land.

3D GLASS SPHERES

In this last project, we pull together a lot of what we've learned so far to create a photorealistic 3D object: a glass sphere, complete with reflection and caustics. Everyone knows about reflection, but you may not be so familiar with caustics. Caustics are the patterns of light you see reflected from shiny objects in bright light, or through transparent refracting objects. The bright spot of light from a magnifying glass as it focuses the sun's rays is one example, the patterns at the bottom of a swimming pool provide another.

▲ 1 This is the background image on which the sphere will be constructed. It's ideal, as there are strong areas of light and shadow that we can align our fake ones with to solidify the sphere's placement in the scene.

▼ 2 This next image is what the sphere will be reflecting. It's a similar desert environment, but it needs a bit of work if it's to serve as a reflection. First, we increase the amount of sky by enlarging the canvas vertically by 50%, then selecting the sky and stretching it up. The cracked earth image is then dragged in to the document, scaled and distorted into perspective using the *Free Transform* tool. The layer needs to be duplicated and moved because it is not quite wide enough.

▲ 3 Blend the earth into the scene by using a gradient layer mask, then adjusting it with the *Hue/Saturation* tool so that it matches the environment. It doesn't have to be perfect. As we shall see, more adjustment is needed.

▲ 4 In order to turn this oblong image into a reflection map, we first have to make it square. Use *Image Size* with the *Constrain Proportions* option disabled to allow us to make the image 1600 x 1600 pixels square.

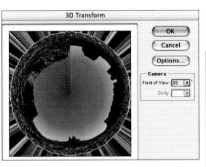

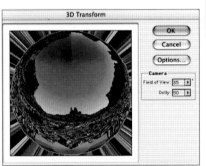

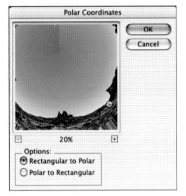

▲ **5** Making the image square is a requirement for the following step: the application of the *Polar Coordinates* filter (see pp 90–3). Running this on the image wraps it into a spherical environment, as if it were reflected in a sphere. Using a wide image, as we have done, helps to preserve the proportions.

▲ **6** This image would be fine if the sphere were viewed directly from above, but the environment needs more adjustment for our needs. We do so using Photoshop's *3D Transform* filter (*Filter>Render>***3D Transform***). First, create a sphere equal to the circular part of the image, then rotate it slightly upwards. This places more of the sky at the top and more of the ground at the bottom. Where there is no image on the sphere, there is still some fixing to do.

▲ **7** To cover the unmapped area, we use a copy of the cracked ground, transformed to fit the square document and spherized (*Filter>Distort>***Spherize***) with the *Amount* set to 100%. Use a layer mask to blend the ground in to the environment map.

◀ **8** Next, eradicate the seam in the sky using the *Clone* and *Healing* brushes, then a bit of *Blur*. Now flatten the image and drag it into the cracked ground document, where you should scale it to roughly the right size before clipping the unnecessary areas away with a layer mask.

▶ ▼ **9** Now we need to add something called the Fresnel Effect. This is where reflectivity increases the more a surface faces away from you. In this case, that would be at the edges of the sphere. To begin with, darken the edges using a white circle on a layer set to *Multiply* blend mode (so it is invisible) and an *Inner Shadow* layer style. The reflection layer is applied over this in *Screen* mode, then the reds desaturated using *Hue/Saturation*.

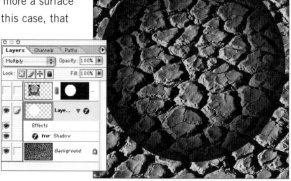

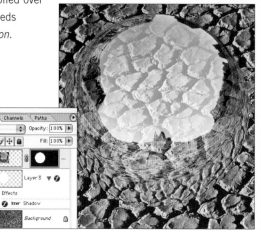

▲ **10** Ensure that only the *Inner Shadow* layer is visible, then *Copy* and *Invert* one of the channels. The result is a Fresnel channel that can be applied as a layer mask to the reflection layer (replacing the old mask). The reflection layer is then duplicated to give the brighter edge and dimmer centre that characterizes the classic Fresnel effect.

▲ 11 In this example, the transparency clashes with the reflection, so it needs to be dampened at the edges to let the reflection show up better. The simplest way to do this is to duplicate the *Inner Shadow* layer.

▲ 13 Specular highlights are added using two circular *Gradient* layers applied with the blend mode set to *Screen*. One is tight and hard-edged, the other wider and softer. By applying a white-black gradient instead of a white-transparent one, you can use *Levels* to adjust the smoothness and size of the highlight. A slight yellow tint confirms that the sun is the light source. The ground caustic is created via the same method. However, instead of *Screen* mode, apply one of the *Gradient* layers in *Color Dodge* mode. This burns out the dark areas better and really helps sell the effect. Finally, adjust the various layer *Opacity* settings to finish the near-photoreal 3D image.

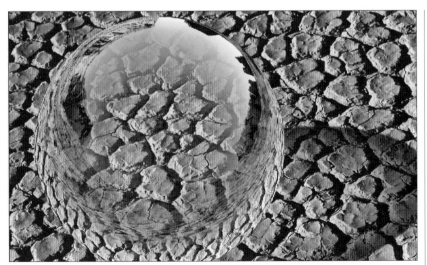

▲ 12 For added realism, you can add a shadow to the background image. The trick to making this work is to take into account the overall light direction and angle. The shadow in this image also has a Fresnel edge. You can use the same technique that we used on the glass sphere in Steps 9 and 10.

3D: CORE CONCEPTS AND APPLICATIONS

While 2D applications can create some impressive 3D imagery, there are some things that can only be achieved with a proper 3D package. This chapter aims to introduce you to the fundamentals of creating 3D graphics, covering every stage from basic modelling to the final render. We will teach you the concepts, explain the terminology, and give examples to show what we mean. Along the way, you will learn tricks that can make all the difference between an artificial 3D scene and a lifelike work of art.

The projects in this chapter aren't tied down to any specific application. Instead, they reveal the basic processes that should be applicable in all 3D applications. While the big-name 3D packages can stretch the expertise (and the pocket) of the 3D novice, cheaper options are available. By the end of this chapter, you should have the confidence to get your hands on one and take your own 3D wizardry to the next level.

HISTORY OF 3D GRAPHICS

To those coming to it for the first time, the subject of 3D graphics can seem daunting. Even if you're an experienced 2D designer, the new terminology and working methods can prove too much to handle. Don't worry. While the 3D world is different, it's really not that difficult to understand as long as you take on board some straightforward core concepts. It also helps if you understand a little of the history behind them.

3D graphics began in the mid-70s when researchers in the US – notably Jim Blinn, Bui-Tong Phong, Martin Newell and Ed Catmul at the University of Utah – began work on 3D computer-generated imaging. One of the first 3D models ever produced was the famous 'Utah teapot':

a 3D representation of a real teapot recreated digitally by Newell and chosen because its curved bowl, spout and handle represented a considerable challenge at the time.

The real 'Utah teapot' now resides in the Boston Computer Museum. As for

its digital version, the model is still celebrated by 3D artists and it comes as a standard 'primitive' object in many of today's 3D programs.

To create these early 3D models, the researchers designed technologies that allowed them to simulate the

THE ONE TRUE TEAPOT

This is the original teapot used by Martin Newell as reference when building his groundbreaking 3D model. Now residing in the Boston Computer Museum, the teapot has near-mythical status amongst 3D geeks. The curved bowl, spout and handle were considered a real challenge by the early 3D pioneers.

effects of light and reflection, shadows and texture on the simple mesh shapes that they had built. Most of this technology survives in some form or another, even in the very latest state-of-the art computer programs.

In those days, the models were not made using tools, since there were no 3D programs as such. Instead they were created manually as a 'description' of the shape of the object's surface in computer code.

Later, simple programs were developed that began to automate the process of creating, lighting and rendering 3D models. These programs slowly improved, and today's 3D programs are quite sophisticated and user-friendly. You might need a couple of days practice before you get to grips with the basic features, but at least you don't need to have a degree in computer science in order to use them.

The legendary Utah Teapot still turns up as a primitive in today's 3D applications, making sure that it remains a familiar sight to 3D designers and enthusiasts.

3D graphics eventually broke out of the university research lab and onto the big screen. This began as early as 1981, in films such as *Looker* and Disney's *Tron*. These days, the latter has a cult following, but at the time its financial failure left the use of 3D graphics in feature films in limbo. This in turn put many of the companies involved out of business.

Luckily, the good work continued. Research flourished, with companies such as Pixar producing incredible short films such as *Luxo Jr.* Confidence was regained when *Jurassic Park* was released with great success, before Pixar's *Toy Story* paved the way for feature-length 3D animations. The rest, as they say, is history.

T-REX Jurassic Park *was one of the first truly successful films that featured 3D computer graphics.*

3D APPLICATIONS

Thanks to a growth in interest and the affordability of high-end PCs and Macs, 3D applications come in all sorts of forms and at every price level. Most are designed for general purpose 3D work – from print and web design through to broadcast TV and video, right up to cinematic special effects. Such high-end packages don't really concern us. Costing thousands of pounds and designed for advanced 3D animation and effects, you will probably need a course just to understand them.

Luckily, there are plenty of packages in the low and mid-range sectors that put ease of use at the forefront. Here are some of the better packages on offer for up to about £1000 (or $1500).

▼ **CARRARA** Carrara is a 3D system that offers a host of features, including high-quality rendering, fast display graphics and a selection of great tools. However, the interface has been designed to look good rather than work well. Available for Mac and PC for around £300.
www.eovia.ccm

▲ **ZBRUSH** ZBrush is the odd one out here. It began, not as a 3D program, but as a special 'z-painting' program which let you paint with depth as if in 3D, but on a 2D canvas where you can't change the view. Later versions added proper 3D support, with a sculpting operation much like that found in Amorphium. Around £250.
www.pixologic.com

TRUESPACE Truespace is a PC-only 3D program with a quirky interface that some love and others loathe. It combines a large number of very powerful tools and the large, single panel interface enables a very fluid way of working once you get used to it. The latest version costs approximately £500.
www.caligari.com

is exceptional, the interface is very user-friendly, and the packages are available for Mac and PC platforms.
www.maxon.net

ELECTRICIMAGE 3D TOOLKIT For $199 (approx £125) the best bargain in 3D is arguably the 3D toolkit by DV Garage. This is a series of training videos on DVD or CD and comes with a copy of ElectricImage Animation System. This is the fastest high-quality renderer on any platform at any price, though it's available for Mac only.
www.electricimage.com

AMORPHIUM Amorphium is an interesting 3D system designed to simulate the way in which a clay sculptor would work. By pushing and pulling on a primitive object while rotating it, you can sculpt 3D objects like you would putty. As a result, objects created with the program have a very organic look, and some professional 3D artists use it to deform models made in other programs. Available for Mac and PC at around £199.
www.electricimage.com

▶ **LIGHTWAVE** At around £1000, Lightwave 3D sits firmly at the mid to high-end of Mac and PC 3D applications and is priced to reflect this. Nevertheless, it is an incredible 3D system capable of stunning results. It's rendering quality is unsurpassed at the price and beyond, and it has been used in countless commercials and feature films as well as by print and web artists.
www.newtek.com

▲ **CINEMA 4D** Cinema 4D XL is comparable to Lightwave 3D in most respects, but as it's offered in modular form it is far more affordable. Prices start at around £165 for the cheapest version and go up to £1999. Modelling

107

THEORY: 3D MODELS

As we have mentioned before, the term '3D graphics' is a bit of a misnomer. Whatever way you look at it, the final result of 3D graphics for print, the web, broadcast or film is a 2D image on a flat screen. The only case where 3D computer-generated models become truly three dimensional is in the field of CAD/CAM where computers can control machinery to manufacture real objects from metal or plastic.

A 3D model consists of a series of points, each of which has a location in 3D space defined by a set of coordinates. Called Cartesian Coordinates, these consist of three values, each representing a value for each axis of the 3D space.

To be precise, the term '3D graphics' refers to the data as it is stored inside the computer. Within a 3D application, a 3D model can be manipulated as if were a real 3D object. It can be moved, rotated and viewed from any angle, then a 2D image can be rendered of that view. In the case of an animation, a series of images can be rendered to make up individual frames.

▶ **VIRTUAL MODELS** You can view a 3D model from any angle in a 3D program and render images to create an animation. In this sense, the model exists in 3D space – albeit a virtual 3D space that exists only inside the confines of your computer.

▲ **WIREFRAME** By joining these points, called 'vertices', together with a series of lines you can create a 'wireframe' object.

▲ **POLYGONS** A polygon is any group of points joined together to form an enclosed region that may then be shaded. The simplest polygon possible is the triangle. This has one special property: it cannot be bent, as all three points always lie on the same plane.

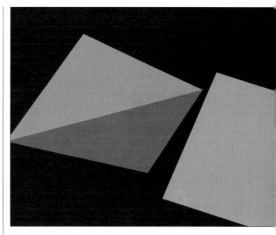

▲ **TRIANGLES** Polygons that have more than three points can be bent and twisted, which can result in 'shading errors'. To avoid this, most 3D programs divide up larger polygons into a series of triangles when rendering. This process is known as 'tessellation'.

▲ **FLAT COLOUR** The gaps between the points and edges are hollow, but you can tell the computer to fill in these gaps with a flat colour that varies depending on their spatial and directional relationship with the light source. Each of these filled faces is a 'polygon', and when they are filled with colour the model is said to be 'shaded'.

COMPLEX MESHES *You can create objects of any shape and complexity from these polygon 'meshes'. You rarely have to connect up the points yourself, as the meshes are formed automatically by high-level modelling processes.*

SIMPLE MODELLING

Before you can render an image, you usually have to create some models. As an alternative, you can buy or download free models from the internet, but it's far more rewarding to build your own. It can also be quite simple to build your own scenes using basic techniques for editing primitives.

▲ **1** The pavement and wall are made from two cube primitives. One is added and scaled up along the z axis and down in the y axis to make a long flat pavement. This is duplicated, then scaled up vertically and moved back to make the wall. For the road, a plane is added and scaled in all directions.

▲ **2** The streetlamp is slightly more complicated than a wall, but it can still be broken down into simpler objects. We begin with a cylinder, which is scaled so that it is fairly tall and narrow. On top of this, a sphere is added and positioned so that only the top hemisphere is visible above the cylinder. The easiest way to do this is to use the orthogonal views to help line up the two objects.

FINAL IMAGE *This is the completed image with added textures and lighting. With detailed textures in place, it's difficult to believe that the whole scene has been built from such a simple set of primitive objects, all of which come supplied with most competent 3D modelling packages.*

▲ 4 To make the bent neck of the streetlamp, we add a torus. Most primitives allow you to edit them, so we make ours much narrower. The torus is then converted from a standard primitive to a simple polygon object. This allows us to select the polygons we don't want and then delete them until we have the right shape.

▼ 5 Finally, a cone is added to make the shade, and a small sphere, given a luminous material, is placed inside to be the light. An orange, shadow-casting *Point* light, placed below, illuminates the street. A dim *Distant* light is also added to the scene, and tinted blue to simulate moonlight. Without it, the rest of the scene would not be visible.

▲ 3 The sphere is grouped with the cylinder to create a hierarchy. By doing this, the sphere will always move with the cylinder and keep its position relative to it. Another cylinder is added and scaled so that it is thinner and much taller than the previous one. This new cylinder is positioned in the centre of the earlier cylinder and a sphere used to cap the top as before.

DERIVATIVE MODELLING

Simple modelling involves moving, scaling and rotating primitive objects into the desired assembly. This is fine for a lot of uses, but as your skill improves you will find that primitive modelling is not as flexible as you need it to be. There are, of course, many other modelling tools in a decent 3D program, and most of these involve deriving a more complicated 3D object or surface from a relatively simple shape.

Imagine making a simple pipe. To derive a cylinder, you create a circle and *Extrude* it along a direction perpendicular to it. To make a torus, you could *Lathe* or revolve the circle 360° around an axis parallel to the circle but outside it. The resulting surfaces are sometimes called 'derivative surfaces' because they are derived from a much simpler object. There is often more than one way to create a certain surface, but it takes thought to find the best approach. Mentally breaking down the object into parts will allow you to find the most efficient way.

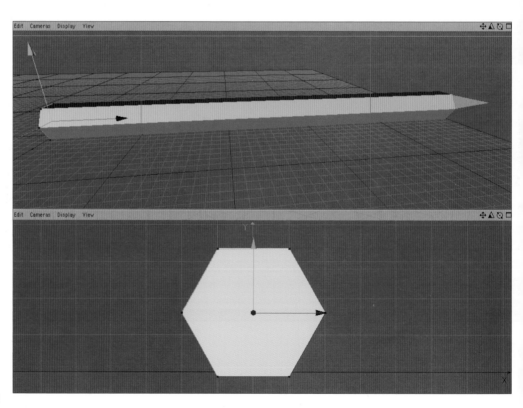

▲ SLICING By mentally slicing an object along an axis, you can discover the simpler shape that the object is derived from. A pencil is simply a hexagon that has been extruded. To form the point, a cone can be placed at the end. It's all quite simple when you think about it.

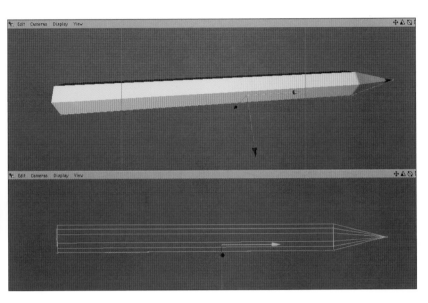

▲ **LATHING** Alternatively, the pencil can be made by lathing a curve that represents half its profile lengthways including the point. The *Lathe* feature in a 3D program will often allow you to specify the number of steps in the lathe, so using a value of six will create the hexagonal shape.

▶ **SWEEPING** The final kind of derivative object is the *Sweep*. This is similar to an *Extrude*, but rather than using the direction perpendicular to the profile, another curve is used. The profile is then swept along the path curve to create the 3D object. This allows all manner of shapes to be created. In this example, we've created a pretzel-like knot.

▶ **LOFTING** Another way to make derivatives, lofting takes several cross-sections and strings a surface over them – like the cross members in a boat hull. The advantage is that the profiles don't have to be the same shape. A vase can start as a circle and end with a fluted top, which isn't possible with lathing.

TIP *Objects that are lathed or swept around an axis will usually have some degree of rotational symmetry. If the object you want to create does not, then you should probably think about modelling it using another method.*

BOOLEAN MODELLING

Boolean modelling is another process that can be used to make complex objects from simple ones, but it works in a different way from primitive or derivative modelling techniques (see pp 112–3). In Primitive modelling, you assemble simple 3D objects like spheres and cubes to make your object. Boolean modelling also uses two or more 3D objects to make a single composite object, but not quite in the same way. Rather than just adding them together, you can subtract them from, or even intersect them with, one another. It can be a tricky concept to grasp, partly because there is no practical real-world equivalent.

▲ **ADDING** Boolean modelling works using three kinds of interaction between objects: *Subtraction*, *Intersection* and *Addition*. *Addition* works like standard primitive-based modelling, combining two objects into one. This time, however, the resulting object is a single form, not a group of different objects.

▲ **ONE OBJECT** You can see the difference in this example. Both objects look the same when viewed in shaded mode, but in wireframe you can see that the part of the icosahedron inside the cuboid still exists in the primitive modelled version (bottom). In the Boolean model (top), it has been removed. This can have consequences if the object is to be modelled further.

▲ SUBTRACTING Subtraction is much more interesting. If we change the Boolean mode to *Subtract*, the one object is removed from the other object as if it were a negative volume. Only the parts where the two objects overlap are affected. In this case an icosahedron-shaped hole is left in the cuboid.

▲ INTERSECTING In *Intersect* mode, only the portions of the objects that overlap are left. In effect, it is the opposite of the *Subtract* operation, where the overlapping portions

disappear. Intersections can be a little tricky to visualize, but if you look at this example, you can see the two original sphere objects ghosted over the Boolean end result.

▲ PUZZLE Notice that the materials of the original objects are retained after the Boolean operation. This is usually an option in most 3D programs. This fact can be used to create all kinds of interesting objects. This broken Greek column was created using Booleans. See if you can work out how.

◄ SOLUTION A terrain object was used to create the broken surface of the column, and a bump map was then applied to it so that the inside appears rough. The fluted sides are made by subtracting an array of cylinders, which were themselves made by using *Addition* on a cylinder and a sphere.

BEVELS: THE MAGIC TOUCH

Detail makes for a good 3D model, and even the simplest 3D model can benefit from the application of one golden rule: no edge is perfect. In the real world, no edge is perfectly straight or perfectly sharp, and it's the latter that makes the biggest difference in a 3D model.

Imagine a cube. A real cube made of metal would have edges that look very sharp, but on closer inspection they would be ever so slightly rounded off. On a wooden cube, this would be even more apparent. These subtle rounds or bevels catch highlights or shadows and separate the shading of adjacent faces with a line. This adds a huge amount of extra detail to a model and makes for a more engaging image.

▼ **STAIRS** If a model has hard edges – in other words, it isn't an organic object like a human figure – it will benefit greatly from having bevels. Here are two models of a staircase, one with bevels and one without. Although we can't actually see the bevels, the difference they make to the object's shading is massive. The right staircase looks flat and unconvincing while the left staircase looks more 'real'.

▲ **CLOSE UP** If we zoom in close, you can see the edges of the cubes that make up each step and riser are actually rounded off. Technically what happens is that, rather than the two sides meeting at a perfect 90° angle, there is a transition – the bevel – which is illuminated differently from the faces because it's pointing in a different direction. This will happen no matter where you place the lights in the scene.

▲ **SEPARATION** Bevels should be applied to all objects where possible. For example, use them when creating objects with interlocking parts. There is no need to have a gap between sections because the bevels will perform the task of separating the different pieces.

▶ NO BEVELS Logos and 3D text are further candidates for bevels. In fact, we'd go so far as to say it's obligatory to bevel text and logos unless you have a really good reason not to. This text object has not been bevelled. Notice that it looks pretty dull and is obviously the raw product of 3D design.

▼ WITH BEVELS With bevels added, the text has extra 'zing' and presence. The new reflections also enhance the solidity of the object, making it look both more convincing and visually interesting.

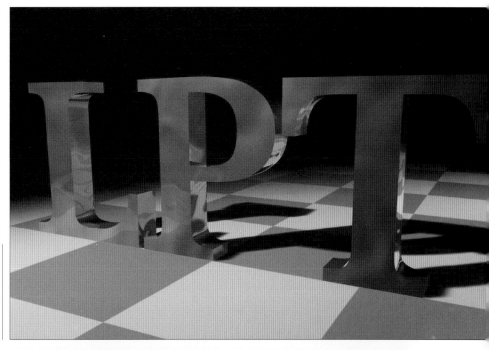

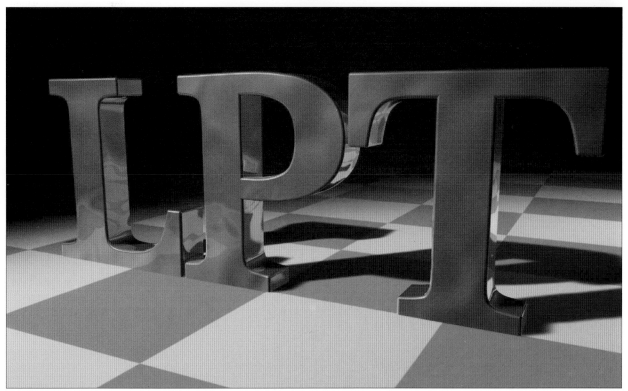

CONVERTING 2D IMAGES

If you are used to 2D drawing applications, you may feel uncomfortable using the more advanced tools in a 3D program at first, but you can just draw shapes in a program such as Photoshop or Illustrator and use these as the basis for a 3D object. The ability to import 2D artwork also becomes useful if you are presented with artwork, such as a company logo, that needs to be transformed into a 3D model.

▲ **3** To ensure compatibility, it's often best to save your work in an older Illustrator format, such as 5.0. Most 3D applications will cope with version 8 Illustrator files, but the later versions could cause problems.

▲ **1** Here is the logo that we want to convert into a 3D model. This might have been supplied by a company or agency, or it could be one you have drawn yourself – often an easier proposition using 2D tools.

▲ **2** Before saving the file, convert any type in the document to paths. Otherwise these might not be imported properly. In Illustrator, you select the type and choose *Type>**Create Outlines***.

▲ **4** This file can now be opened or imported into your 3D program. Different applications will handle the file in different ways. Here, in Cinema 4D XL, the paths are converted to Bézier curves. In Lightwave, however, the shape would be converted directly into polygons.

▲ **5** In this case, the three elements come in as three separate spline curves, which we can extrude to form the 3D object. Here is the result, the Illustrator file converted to a 3D object in just a few steps.

▶ **6** Once the Illustrator artwork is inside the 3D program, you can do whatever you like with it. Here, we've added some bevels to the edges to make the object look more real, and modified the material to make it appear reflective. An environment map adds some global reflection, since there is nothing else in the scene to reflect.

THE VIRTUAL CAMERA

We know that 3D models are formed from a mesh of connected vertices that have coordinates in the virtual 3D space. In order to see this model on screen, another point must be defined – the viewpoint. This is like any other point in the 3D scene in that it has a set of coordinates, but with one important distinction: this time, there is no geometry, it is simply a location that the computer uses to place the 3D virtual camera.

A regular, photographic camera has a number of components. It has a lens through which light passes, a shutter which restricts the flow of light, a body, and – inside that body – film which records the patterns of light that have passed through the lens and the shutter.

The virtual camera in a 3D program has similar properties. There is no lens as such, but we can give the virtual camera properties to make it act as if it did, changing its angle of view and telling it to zoom in on an area of the scene. There is no film either, yet we can tell the computer to form an image of the 3D model, taking into account the parameters of the virtual camera. Because we have given it a location and a viewing angle, perspective happens naturally. However, as this is a virtual world we can even disable perspective if we want.

▲ **1** Here is a 3D scene as viewed from a 3D camera. The natural perspective that we get in the generated image helps the viewer to judge the relative positions and sizes of objects.

TIP *Most 3D programs have the views in Step 3 already set up. They are usually called* Top, Left *and* Front *(or conversely* Bottom, Right *and* Back*) and are known as 'orthogonal views'.*

▲ **4** By altering the field of view on a camera, you can create extreme perspective distortion. For this example, we have moved the camera in close but zoomed the view out, so widening the field of view dramatically. The result is that objects near to the camera appear seriously distorted.

▲ **2** When we switch off perspective, it becomes difficult to visualize object placement in all three dimensions at once. The lack of perspective means that objects which are the same size do not diminish as they recede. The result looks quite strange.

▼ **3** This can be a benefit – especially if we set up three such cameras so that they point directly in line with each of the three world axes. This allows you to get an overview of your scene and accurately align objects in space, no matter how far apart from each other they are.

TIP If you're working with 3D cameras and views, it helps if you understand the language. Some of these terms have their origins in photography or cinema, others are unique to the 3D world:

Dolly – to move the camera in and out in the direction of view.

Zoom – changing the field of view while keeping the camera stationary.

Pan – rotating the camera while keeping its position the same (as if on a tripod).

Orbit – rotating the camera around a reference point, usually the object it is pointing at. The camera is changing position and orientation at the same time to keep the target in view.

Roll – rotating the camera around its own view axis.

LIGHTING

In order to make a 2D image of a 3D scene, you need to 'render' it, a process where your computer calculates the colour and brightness of each pixel in the image, taking into account the objects in the scene and their orientation to the camera and lights.

You can't render a scene without lights, so these are of paramount importance to the final look of the scene. Lights are similar to cameras in that they are represented by a point in space with some associated parameters. Like real lights, they cast illumination on the scene, and it's by calculating the effects of the lighting that the correct shading can be applied to objects in that scene.

▼ **SHADOWS** By analysing the scene from the point of view of the light, the software can also calculate the fall of shadows in the scene. A shadow is simply a part of the scene that cannot be seen from the point of view of the light – for example, where one object is hidden behind another.

▲ **VISIBILITY** The view from a light. Everything that is visible in this view will be illuminated by the light. As the ball is hidden behind the teapot, it will be in the shadow cast by it.

▲ POINT LIGHT 3D programs offer a variety of light types. This is a *Point* light, which emits light in all directions like a naked bulb. Notice that the shadows extend radially from the centre of the light. Rotating the light will have no effect on the illumination.

TIP *There are more light types available in most 3D programs than the three outlined here.* Area *lights, for example, are lights where the source of illumination is spread across an area, a square or a disc. The resulting illumination is more diffused than the standard type, so the effect mimics that created by a photographer's lightbox diffuser.* Linear *lights are similar, except their illumination is spread only along one axis, like a fluorescent strip light.*

▶ SPOTLIGHT A *Spotlight* is like a point light that is being shone down a hollow cone, which focuses the light in one direction. In most 3D programs, you can vary the spread of the light cone using the *Cone Angle* parameter. Rotating the light affects where the *Spotlight* illuminates the scene.

▶ DISTANT LIGHT A *Distant* light is a special kind of light that simulates a *Point* light that is infinitely far away. To all intents and purposes, our sun is such a light. Moving a *Distant* light has no effect on its illumination, while rotating it does. If an object with parallel sides casts a shadow from a *Distant* light, notice that the shadow will also have parallel sides, unlike the *Spot* and *Point* lights. Another way to think about a *Distant* light is as a light that has no location, only direction.

SIMPLE LIGHTING RIGS

Lighting is crucial in achieving great 3D imagery. A poor lighting setup will waste all the hard work you've spent on modelling and texturing the scene, but there are some hard-and-fast rules you can apply to get started. The more you practise with different lighting setups, the better and quicker you will be at setting them up. It also helps if you have a grasp of the basic theory, which is exactly what you'll find here.

▲ **KEY LIGHT** It's perfectly possible – even advisable – to mimic studio photographic lighting techniques when you are designing 3D lighting rigs. There are two simple setups that you can learn: the 'two-point' and the 'three-point' lighting rig. Both setups start with a main source of illumination called the 'key' light. This is usually placed towards the front of the scene, so that it illuminates the main object from a point slightly off to one side.

▲ **FILL** The key light provides the main illumination, but notice that the side in shadow is totally dark. Another light can be added to 'fill in' this shadow area with a low level of illumination. This light, called a 'fill', is placed on the dark side and roughly level with the object being illuminated (although a position slightly forward or back from this is often used for effect). The fill's intensity is lower than the key.

◄ **COLOURS** Another trick is to tint the key and fill lights with contrasting colours. For example, the key might be a warm yellow and the fill a cool blue, or vice versa. Either way, adding a fill helps to separate the whole of an object from its background. This classic two-point lighting rig is useful for setting up lighting in many different situations.

▶ **BACKLIGHT** The three-point lighting rig builds on the two-point by adding a 'backlight', sometimes called a 'rim' light. As in the real world, this has the effect of forming a bright halo, or 'rim' around the subject. If the subject is a person, the semi-translucent hairs over the skin or fibres in fabric catch the light and help the effect. In a 3D application we don't have the luxury of these fine hairs so the placement of the light will be different. In a studio, the backlight can be directly behind the subject, but in

3D we have to move the light to one side in order for the 'rim' effect to appear. Because of this, two lights are often used to balance the effect.

Whereas shadow casting for the fill is not always necessary, the back lights do need to cast shadows, so make sure you have this option switched on.

RENDERING

When you render the final artwork or animation, your 3D application takes all of the light and shadow information into account, along with the properties of the objects and their surfaces. As a result, the final render can take a long time to complete.

The final artwork needs to be free from artefacts, including jagged lines (aliasing), and in many cases needs to be produced at a very high resolution. The image is usually rendered to a file on your hard drive, though it may also be displayed on screen as it progresses so you can keep a track of the final result. While today's computer hardware can render impressive 3D graphics in real-time, photorealistic results still demand vast numbers of calculations.

▲ **ALIASING** Antialiasing is one of the main factors in producing a final rendered image of suitable quality. Without antialiasing, a digital image can suffer from blocky artifacts or ugly, jagged edges. This can cause problems when we're trying to achieve a sleek or realistic look.

▲ **PROCESSING** This is an image being rendered. The display shows the various stages that the software goes through to rid the image of artefacts, the main one being antialiasing. While it is being rendered and displayed, it is also being saved to a file on disc. This whole process can take a long time.

▲ **ANTIALIASING** Antialiasing smoothes out the jagged edges by rendering a region around a given pixel and then averaging colours to blend the jagged lines with the background. The higher the antialiasing, the more pixels are rendered and the longer it takes, but the result is much more effective.

▲ **REAL TIME** With Graphics
hardware that supports OpenGL, you
can see changes to your scene being
performed in real-time as you work.
Different display modes are available.
Here objects are displayed textured,
shaded, in wireframe and as a bounding
box. As the level of detail decreases, so
the speed at which the scene can be
manipulated increases.

▲ **RAYTRACING** Software
rendering can also achieve effects that
are not possible using OpenGL. Typically
this involves 'raytracing', a technique
that follows imaginary rays of light on
their path through the 3D scene. The
rays bounce off reflective objects and
pass through transparent ones until they
hit something that stops them (a matte
surface, for instance). Raytracing
creates images of great realism, with
accurate reflections and refraction.

RENDERED TEXT

Here is a basic example of modelling, lighting and rendering in action. This project also shows off some of the benefits of working in 3D: these type effects might just be possible using Photoshop, Illustrator and the rest – but not without some effort and a bag full of visual tricks. We will create type that is embedded in a diaphanous block; a simple but useful device that has no 2D equivalent.

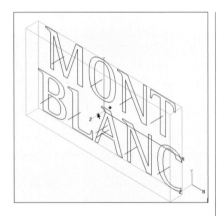

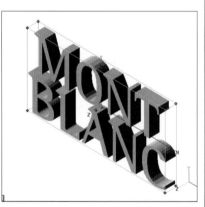

▲ **1** The first thing is to bring your type or logo into the 3D program. Many 3D programs allow you to generate type directly in the application, but this may not be desirable. In this case, we have imported type saved as an EPS file (which most 3D programs can read).

▲ **2** Once imported into the 3D program, the type is displayed as a series of curves, and you can make models from these 2D curves using the normal 3D tools available. Here we have simply extruded the curves to create the final 3D text object.

▲ **3** The text can be viewed from many different angles in a 3D program, but you will be required to add a camera to the scene through which you will actually render the final image. Here's the view of the text, displayed in wireframe mode, through the 3D camera. We have also added the block object, which is big enough – and thick enough – to engulf the text.

TIP *When you're creating text like this in 3D, bevels are particularly useful. Adding an extra face between the front and side faces of the text, at an angle of 45°, helps to delineate the front of the typeface, adding interest and making the text more readable and realistic.*

▶ **5** The final step is to design the transparent material for the text. You can easily design both realistic and highly stylized materials in a 3D program, and in this example we've applied an environmental reflection map to the material.

▲ **4** The scene is lit using the 3D program's global lighting panel. We select a single distant light source. A test render of the scene with some basic materials applied to the 3D objects usually provides the best way to judge that the lighting is set up correctly.

▶ **6** For the final render, we have decided to change the camera's viewpoint. One of the advantages of doing this project in a 3D program is that it allows us to make even such fundamental design alterations right up to the last minute.

APPLYING TEXTURES

Texture mapping is a term applied to the process of wrapping bitmap images around 3D models so that they look more like the object they are supposed to be. For example, a photo of wood grain can be applied to a table model so that, when rendered, it looks like a wooden table. Texture maps are usually applied in one or more 'channel' of a material. Texture channels are the sub-components of a material – Color, Luminosity, Reflection, Specular, Bump and the rest – and a bitmap texture can be applied to any or all of them.

▼ **3** However, we can improve the effect even further. By editing the texture in Photoshop, we can make a better bump map that makes the mortar much deeper (by darkening those areas) and the bricks smoother (with a *Blur* filter). The bump map only needs to be in greyscale to work.

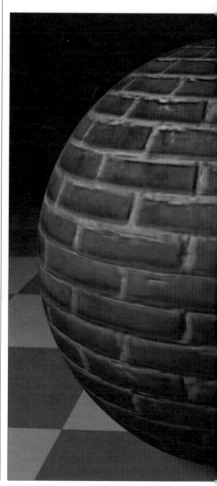

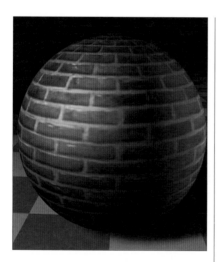

▲ **1** Texture maps applied to the *Color* channel of a material can make objects look like they are made from different substances. More importantly, they provide an impression of surface detail without a need for any further modelling. Here is a sphere primitive with a brick texture applied in its material's *Color* channel.

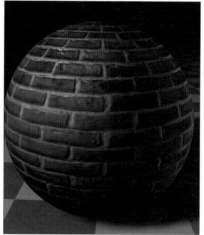

▲ **2** The object looks fairly realistic but the surface looks too smooth to be convincing. We solve this with a bump map: a texture that adds a simulation of relief to the main object texture. Applying the brick texture in the *Bump* channel gives a rougher look, and because we used the same image the bumps line up with the *Color* channel.

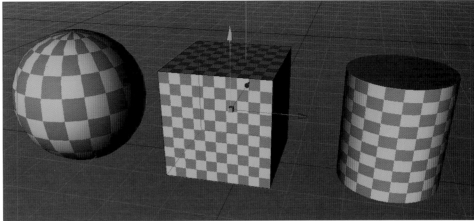

TIP *Most 3D programs let you apply a bitmap only to the surface of objects. This is because the renderer creates pixels, not vectors. If we want to use a vector drawing, the best thing to do is to convert it to a bitmap first.*

▲ **4** When textures are applied to objects like this, they have to be wrapped, or 'projected' around the object somehow. In the case of simple objects, such as spheres, cubes, cylinders and planes, it's pretty easy.

The 3D software has a number of preset projection methods, and you can choose the one that best matches the shape of the object. Typical presets include *Spherical*, *Cubic* and *Cylindrical*, and you can see how they work above.

▲ **5** In the case of each projection method, the texture is warped to the projection shape internally by the software, then projected inwards onto the object. You can use these standard projections on more complicated objects, but you end up with 'smearing' where the surface doesn't point directly towards the texture.

▲ **6** A different projection type can help in reducing the effects of 'smearing' where the texture warps as it is projected onto the object. In this case, the *Spherical* projection has been replaced with *Cubic* projection, resulting in much less smearing on the figure.

ADVANCED SURFACING

Using texture maps, you can change the appearance of objects, their colour and their surface bumps, so that they look more detailed than they actually are. You can also use texture maps in channels such as Reflection, Specular and Luminance to provide further effects. In these channels, only greyscale images need to be used. The brightness values in the image are used to control the brightness of that channel's effect on the surface.

Procedural textures are an alternative to bitmap textures and are built in to the 3D programs. These generate colour or greyscale patterns during rendering and can be used in texture channels just like bitmaps. The advantage is that they are resolution independent, unlike bitmaps, which have a fixed size.

▼ **1** This is the bitmap image we are going to use. It's a simple X on a plain black background.

▼ **2** By applying the bitmap image in the *Reflection* channel of a material, we are telling the software to make the object 100% reflective where the image is white and 0% reflective where it is black. This gives us complete control over which portions of an object will be reflective, and to what extent.

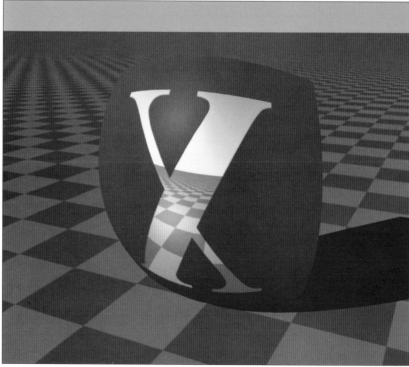

TIP *Specular image maps help prevent 3D objects from looking too clean and unnatural. Most objects that are shiny also have scratches, marks and dents in their surface that help to break up the specular highlights. A good specular map will work wonders in this respect.*

▲ **3** Likewise, the same map applied in the *Specular* channel of a different object causes the specular highlight to appear only where the white X is on the surface. Because the highlight location is dependent on the viewing angle and light position, it can be tricky to see this effect on the static page.

▶ **4** Applying a fractal image to the *Specular* channel of a material (such as Photoshop's *Clouds* filter or, in this case, a procedural texture) can add realism to an image, as few objects have perfectly clean surfaces. This can also be a good way to get certain metallic effects – zinc plating, for example.

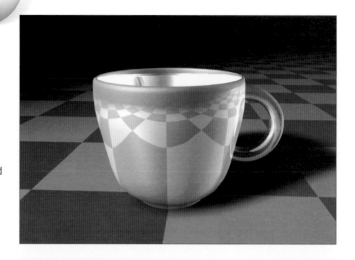

▶ 5 Where reflection is concerned, a special procedural texture can be applied called a *Fresnel Shader*. Its effect is best described by example. Here is a ceramic cup. Like most glazed ceramics, it's reflective, but just applying refection doesn't work terribly well, since the reflection level is the same across the cup's surface.

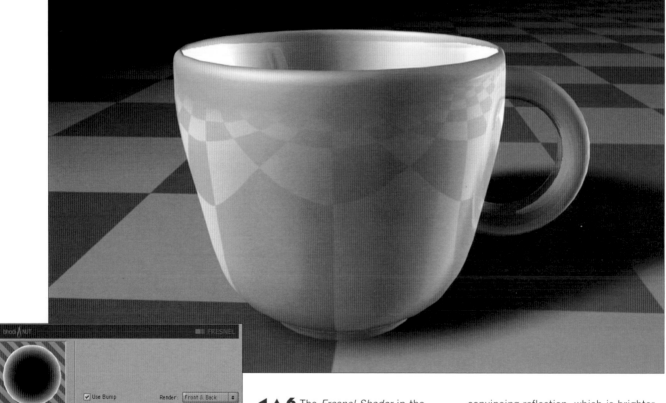

◀ ▲ 6 The *Fresnel Shader* in the *Reflection* channel causes the reflectivity to fall off the more the surface faces us. This is what happens in reality, and the result is a more convincing reflection, which is brighter at the edges of the cup. The *Fresnel Shader* interface lets you control the effect using a simple gradient – white is 100% reflective, black 0% reflective.

▲ **WAVES** By combining procedural textures with displacement mapping and some skilful modelling, we can create some stunning, highly believable effects. This image of a stormy rolling sea was created in Lightwave 3D 7.5, which has an excellent procedural texturing system. Note that, although the sea is obviously water, there is no transparency used in the surface material – in the dark and stormy conditions we're trying to capture in this render, the sea looks black and solid. In 3D, you should always recreate what you would actually see, not what you think you know!

RECONSTRUCTING REALITY

As we've said before, good 3D work is all about detail – even the simplest shapes can end up as complex objects if they are designed to be examined close up. This project is a perfect demonstration. Nothing could be much simpler than a snooker cue, but creating a lifelike result isn't as easy as it seems.

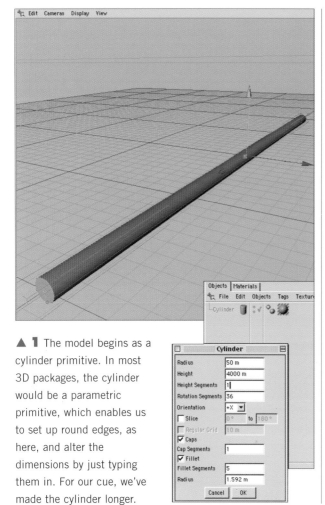

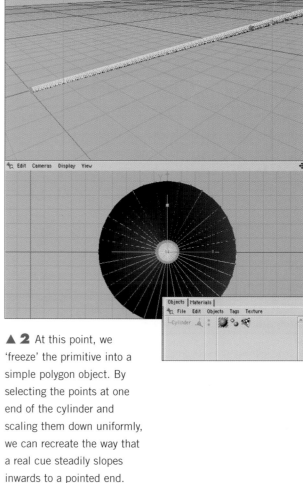

▲ **1** The model begins as a cylinder primitive. In most 3D packages, the cylinder would be a parametric primitive, which enables us to set up round edges, as here, and alter the dimensions by just typing them in. For our cue, we've made the cylinder longer.

▲ **2** At this point, we 'freeze' the primitive into a simple polygon object. By selecting the points at one end of the cylinder and scaling them down uniformly, we can recreate the way that a real cue steadily slopes inwards to a pointed end.

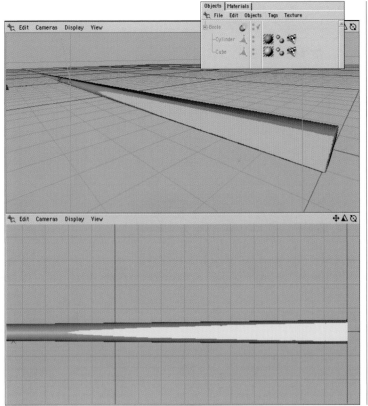

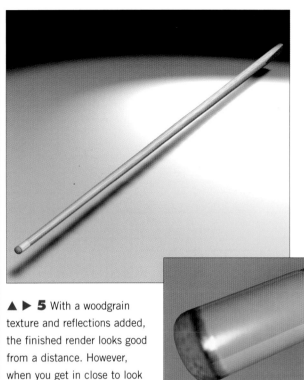

▲ ▶ **5** With a woodgrain texture and reflections added, the finished render looks good from a distance. However, when you get in close to look at the tip, the effect isn't quite so realistic.

▲ **3** We create the flat edge at the other end of the cue by using a cube in a Boolean subtraction operation to cut away from the basic cylinder.

▶ **4** The tip is added as a separate cylinder with rounded edges, closely butted on to the pointed end of the cue. The tip is then treated with a reflection map. Where the image is black (the chalky tip), it won't be reflective. Where the image is white (the metal surround), it will be.

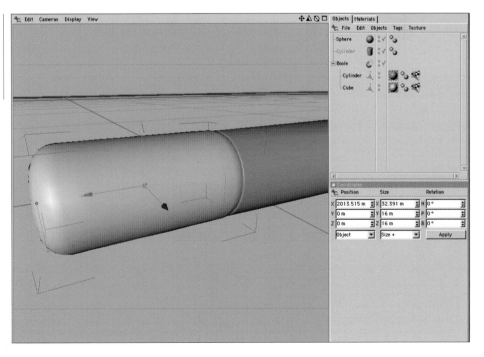

▲ **6** We can improve the effect with a new tip, again created from a cylinder with rounded edges. Because we want more detail, we need a higher resolution model with a finer mesh.

▲ **7** We then add two more rounded cylinders to create a leather washer and a brass collar for the cue tip. Again, using a high resolution mesh gives us more options to add extra detail later on.

▲ **8** In real life, objects don't often have perfectly uniform or symmetrical shapes and recognising this is a key part of creating convincing 3D images. 3D applications usually include tools that enable you to sculpt the polygon meshes in a much more 'hands-on' way. Here, we use them to deform the tip of the cue, and then add convincing dents and other signs of wear and tear.

▶ 9 As the tip now exists in three sections, we can texture each independently. Instead of using a texture map on the end-section, we layer procedural textures on top of it. The first layer is a layer of noise, which creates the colour and the basic bumpy texture. A *Fresnel Shader* lightens the areas that point away from the camera. On top of this goes another layer of noise to simulate the chalk, and finally one more noise layer to recreate the effects of years of hard use on the tip.

▼ 10 Another *Fresnel Shader* gives the middle section a convincing fabric texture, and beneath that we use a brass material for the collar, with another *Fresnel Shader* used to control the reflections. When fully rendered with some balls and the green baize beneath, the finished cue looks very convincing.

USING POSER

The human form is one of the most difficult models to create and animate in 3D. We are finely attuned to reading minute details in the body language and facial expression of other. For a 3D artist, getting these details right is almost impossible, especially during the modelling stage. Tiny variations in muscle and bone structures, eye placement and orientation need to be extremely precise in order to make a 3D model that is convincing without looking slightly strange.

Curious Labs' Poser is dedicated to this very task. Focusing on one specific area of 3D – the creation and animation of realistic human characters – it doesn't even allow primitive modelling. You use Poser for rendering figures; nothing more, nothing less.

▲ **MODELS** The figures are constructed with unbolt controls for adjusting the positions of limbs. You can do this by dragging them directly or by using special 'dials' in the interface.

▲ **FIGURES** Poser comes with a number of specially pre-built figures of varying levels of detail, covering everything from mannequins to skeletons to realistic humans. While your figures can be left buck naked, a range of clothes and costumes can also be added.

POSING *Ease of use is the essence of Poser, and to this end you can pose figures by calling on a library of presets. This library is categorized and the list is extensive. Animation is achieved by 'keyframing' a pose at different points in time. Poser smoothly interpolates frames between these poses, and there are lots of rendering options too. Here a 'hidden line' wireframe style is used, in which lines that would be hidden from view are removed, for a more solid appearance.*

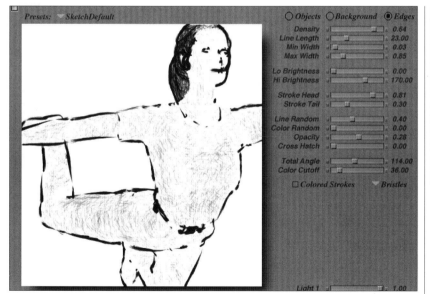

▲ **SKETCHING** You can render frames using the display renderer or the higher-quality software renderer. There is also an option to create non-realistic sketch style renders, which can be very useful for illustration purposes.

▲ **WALKS** The walk designer offers an automated method of creating your own distinctive walking movements. All you need to do to make your characters walk around is to apply the designer and modify the parameters to create a custom walk.

MODELLING LANDSCAPES

What Poser does for figures, Corel's Bryce 3D and E-on Software's Vue d'Esprit do for landscapes. In fact, while Bryce has been designed with this task in mind, it isn't limited to it; it can be leveraged to produce 'standard' 3D renders too.

Bryce was the first of the two, and made quite a stir in the 3D market when first released, for the simple reason that it was easy to use. Novices could get to grips with Bryce fairly quickly, creating (then) spectacular images of craggy mountains in glistening infinite seas. The downside was that this type of Bryce imagery rapidly became clichéd and should now be avoided at all costs. If you are prepared to put a bit more effort into using it, Bryce is still a serviceable 3D system, albeit one with a few limitations.

▼ **PRIMITIVES** Bryce comes with a number of simple 'primitives' – ready-made 3D objects like cubes, spheres, planes and cones, all of which can be used in conjunction to create more interesting 3D models, just as we saw on pages 110-11.

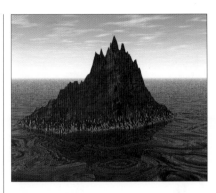

▲ **TIRED** Craggy mountain, infinite ocean, perfect sky. These are the kinds of images that can be produced in a few seconds in Bryce and require zero thought or talent. Think long and hard before inflicting the world with more of this desperately poor 3D imagery.

6 objects
583 polygons
00:00:00.00

▲ **SEE THE LIGHT** If you look around a room, you'll notice that most objects in it can be broken down in this way. A lamp, for instance, is just a few cylinders with a sphere for the bulb and a truncated cone for the shade.

▲ ASSEMBLY More complex objects can be created by assembling lots of primitives together. There is really no limit to what can be achieved with this construction method, so long as you have enough time. Take this intricate robotic example.

▲ MATERIALS Both Bryce and Vue d'Esprit allow you to get deep inside the program if you want, particularly where materials and textures are concerned. Both major on procedurals – materials that are generated by algorithms, like programs that work inside the main program to produce textures for objects. These materials are generated at render time and can be viewed as closely as you want without looking pixelated. Unlike conventional bitmap textures, they can be regenerated on demand.

TREES *If you want to create images of landscapes, then Vue d'Esprit is an excellent package. Not only does it offer terrain editing and impressive atmospheric effects, it also manages lifelike vegetation. Bryce 5 has trees but they are a little clumsy. Vue d'Esprit offers a much more realistic library of trees, shrubs and other flora with which you can populate your scene. Trees and bushes can be added and duplicated as required, while the program's sophisticated SolidGrowth technology ensures that each one is different from its brethren.*

CHARTS IN BRYCE

While many new users open Bryce and immediately begin work on another rocky island landscape, this most approachable of 3D packages has many other uses. As an example, Bryce is very adept at producing distinctive 3D charts, which can add colour and texture to even the dullest report or presentation.

▲ BLOCKS Bryce's simple primitive tools can generate block diagrams in a matter of minutes. You can use the size fields to add accurate dimensions. This example took just ten minutes to construct and render.

▲ ◄ VIEWS

Here's the rendered chart. The immediate advantage of using a 3D application is that you can quickly rotate the image or alter the perspective. You can tailor a graph or chart so that it suits a layout or emphasizes (or even hides) a statistic.

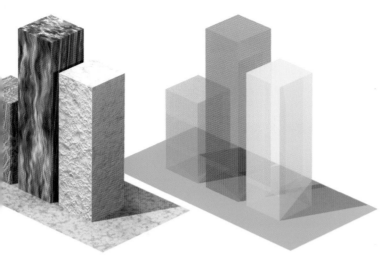

▲ TEXTURE EFFECTS

Another plus is that it's just as easy to add eyecatching effects, through the simple application of attractive textures or transparency. Again, with Bryce these changes take only a few minutes to set-up and little more time to render.

▼ ON THE MONEY

This simple illustration was performed by creating the large cube, resizing it to the appropriate smaller dimensions, then using a Boolean subtraction to remove the one from the other. It still maintains all the old surfacing and lighting characteristics. A new cube with the smaller dimensions is then added with a different surface texture.

▲ PIECHARTS

Bryce also lends itself to other basic but effective chart effects. In this example, we've used a subtraction operation to create piecharts from discs, which are then treated with a mixture of reflection, refraction and transparency effects.

▼ BALLS

Or you can leave conventional methods of representing values behind. Why stick with boring bars when you can use these attention-grabbing glass balls?

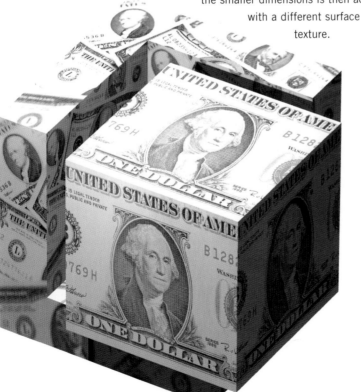

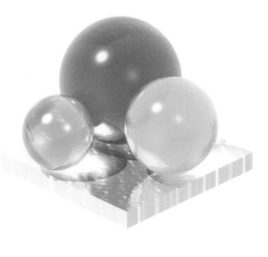

COMPOSITING 3D OBJECTS

We started this book working in 2D, but 2D tools also have a part to play at the end of the 3D process. 3D programs output RGB images, but this output may not necessarily be the final work. You can – and many 3D artists do – make changes to the rendered output in Photoshop. You can also choose to save an alpha mask along with the RGB image, so you can easily cut out the background from the render to isolate one or more objects in the scene. This makes compositing a 3D object over a photographic background – perhaps to incorporate it into an illustration – that much easier.

▼ **1** Here's our 3D object, a flying saucer, rendered in our 3D program. We want to composite this over a background image in Photoshop. Why not use the photo as a background in the 3D program and render the image complete? Well, we may want to make adjustments to the colour, size and position of the saucer over the background, and doing this in 3D will be very time-consuming.

▶ **2** Instead, all we need do is render the saucer once, along with an alpha mask, so that we can remove the black background and composite the result in Photoshop. Here's the image, and this is the alpha mask – both are part of the same file. This is possible only if you use an image format that supports alphas, such as 32bit TIFF or TGA.

◀ **3** Load the alpha channel as a selection and apply it as a layer mask to the background layer. In order to do this, we must convert the background layer to an ordinary layer. Double-click the background to access the *New Layer* dialog, then click OK to make the change.

▶ **4** Now the mask can be added to the layer. Do this while the selection is active by clicking on the *Add Layer Mask* icon at the bottom of the *Layers* palette.

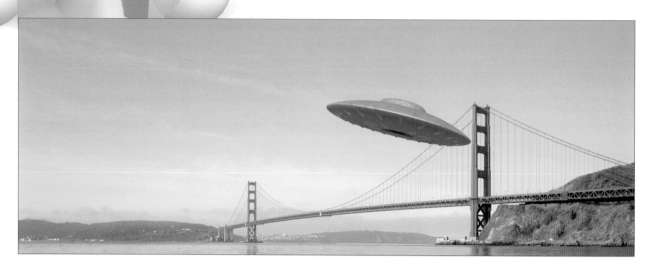

▲ **5** We can add the saucer to the background photo by dragging its layer into the open document. Now we can freely move and scale the saucer to position it in the most effective way in the final composite image.

▼ **6** If we zoom in close, however, we notice a slight problem. There is a black line all around the saucer – a part of the original background showing through the antialiased edges. While not disastrous, it does spoil the image slightly.

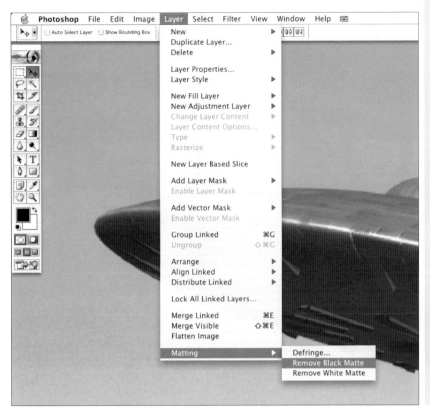

▲ ▼ **7** To fix this, drag the layer mask to the trash, and accept its application on the layer. Now choose *Layer>Matting >Remove Black Matte* and – hey presto! – the black line vanishes and the seamless composite is complete. We can even add extra saucers by duplicating and scaling the main saucer layer. One single render can become an alien armada in seconds.

CREATE ALPHA CHANNELS

Almost all 3D programs have the ability to create an alpha channel when you render. However, you may have a complex scene in which you want only one of the objects to have an alpha mask, or you may have a 3D program that does not create alpha channels automatically. Either way, you can always create them manually, regardless of your 3D application.

▲ **1** Here is a scene that we want to have some control over after we render it. Specifically, we want to be able to take the spaceship in the foreground and adjust it independently from the star background, which is nothing more than a very large sphere with a starfield texture applied to it.

▲ **2** If we just render an alpha channel, all we will get is a totally white alpha. That is because the large sphere is being added to the alpha channel along with the other objects, and since it fills the frame, the alpha will be totally white. We need to be able to remove certain objects from the alpha mask calculation, which some 3D programs allow you to do. Many don't, but luckily there is a workaround. First we make a duplicate of the scene file, then change all the materials in the scene to flat black, except the object we want to appear in the alpha, which we give a 100% white material.

▲ 4 With both open in Photoshop, drag one of the channels of the fake alpha document onto the RGB image. Do this while holding the Shift key to make the channel fit centrally. As it was a channel we dragged, Photoshop places it as a new alpha channel.

▼ 5 This can be loaded as a selection so that we can make adjustments to that object alone – in this case, by using a *Hue/Saturation* adjustment layer to add a green shade to the spaceship.

▲ 3 This is not quite right because the object is still being shaded. What we want to do is make the object fully luminous so that it renders totally white. 3D programs differ in their method for doing this. You'll need to set either the *Luminance* or *Ambience* channel to 100% to get the right effect. What this does is to turn the RGB render into an alpha mask. You can render this image along with the normal RGB render from the scene you saved to give you your main RGB and alpha images.

DEPTH EFFECTS

Even specialist 3D artists don't rely on 3D applications for every aspect of their images. Most will also use a 2D image-editor at both ends of the creation process: creating the bitmap textures for their 3D objects in the first instance, and as a means of modifying the final artwork in the last. One way of putting the final 3D composition together is through the use of alpha channels. For example, an object can be isolated in the image by rendering an alpha mask for it in the 3D program, allowing the object to be edited in Photoshop after rendering. More interesting effects can be achieved using depth masks.

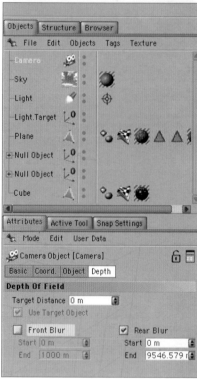

▲ **1** In this example, we'll render out an image of a simple cityscape from a 3D program and edit it in Photoshop, while still maintaining the depth information in the image. Here is the original scene in the 3D program.

▲ **2** As well as rendering out an RGB image of the scene, we can save the depth information from the camera's point of view by rendering a depth mask. Depending on your 3D package, this will be a file or – as in this case – an alpha channel in an RGB image file, which saves the scene's depth information as a series of greyscale values.

▲ **3** Opening
the image file
in Photoshop, we can load the depth
alpha channel as a selection and apply
it as a layer mask to a new channel. By
rendering some clouds in that channel,
we can create fog and clouds which
react properly to the scene depth.

▼ **4** By applying *Levels* to the layer
mask, you can have precise control of
the transition from foreground to
background. In this example, we have
turned the diffuse clouds into a thick
wall of smoke by increasing the contrast
in the mask.

▲ **5** We can even create more optical
effects using a depth mask. By loading
it as a selection, we can *Blur* the image
to create a depth-of-field effect.
However, trying this with a large *Blur*
produces this ugly 'halo' effect, which
doesn't look totally convincing.

▲ **6** The trick to this effect is to use a
very small *Blur* radius, perhaps 1.0 or
2.0, and apply it many times until the
level of *Blur* is reached. Such
convincing results would have been
difficult to achieve using the 3D
package on its own.

GLOSSARY

3D Three dimensional. In graphics, any effect that produces the illusion of depth from a flat page or monitor.

Aliasing The jagged edge which appears on bitmapped images or fonts when the resolution is insufficient or the image has been heavily enlarged. This is caused by the pixels – which are square with straight sides – that make up the image becoming visible. Sometimes called 'jaggies'.

Alpha channel A place where information regarding the transparency of a pixel is kept. In image files this is a separate channel – additional to the three RGB or four CMYK channels – where 'masks' can be stored.

Animation The process of creating a moving image by rapidly moving from one still image to the next. Traditionally, this was achieved through a laborious process of drawing or painting each 'frame' (a single step in the animation) manually on to cellulose acetate sheets ('cels', or 'cells'). However, animations are now more commonly created with specialist software that renders sequences in a variety of formats, typically QuickTime, AVI, Flash and animated GIFs.

Antialiasing A technique of optically eliminating the jagged effect of aliasing, usually by blending the colour at the edges of the object with the background colour.

Area light A special type of 3D lighting that emits from a larger 2D area rather than a single point.

Axis An imaginary line that defines the centre of the 3D universe. In turn, the x, y and z axes (width, height and depth, respectively) define each of the three dimensions of an object. The axis along which an object rotates is the axis of rotation.

Bevel To round or chamfer an edge so that it looks more realistic and, by reflecting light, adds interest to a 3D render.

Bitmap Strictly speaking, any text character or image composed of pixel blocks. A bitmap is a 'map' of 'bits' which describes the complete collection of the bits that represent the location and binary state (on or off) of a corresponding set of items, such as pixels, which are required to form an image, as on a display monitor.

Blend The merging of two or more colours, forming a gradual transition from one to the other. Most graphics applications offer the facility for creating blends from any mix and any percentage of colours.

Boolean Named after G. Boole, a 19th-century English mathematician, Boolean is used to describe a shorthand for logical computer operations, such as those that link values ('and', 'or', 'not', 'nor', etc., called 'Boolean operators'). For example, the search of a database could be refined using Boolean operators such as in 'book and recent or new but not published'. 'Boolean expressions' compare two values and come up with the result ('return') of either 'true' or 'false', which are each represented by 1 and 0. In 3D applications, Boolean describes the joining or removing of one shape from another.

Bounding box A rectangular box, available in certain applications, which encloses an item so that it can be resized or moved. In 3D applications, the bounding box is parallel to the axes of the object.

Bump map A bitmap image file, normally greyscale, that is most frequently used in 3D applications for modifying surfaces or applying textures. The grey values in the image are assigned height values, with black representing the troughs and white the peaks.

Camera In 3D, a virtual device used to define a viewpoint for rendering. 3D

cameras tend to have controls that mimic their real-world counterparts, such as zoom and field of view, lens type, shutter speed, etc.

Camera moves A feature of 3D applications that allows you to perform typical film and video camera movements in animated sequences, such as 'pans', 'tilts', 'rolls', 'dolly shots' and 'tracking shots'.

Cartesian coordinates A geometry system employed in 3D applications. It uses numbers to locate a point in 3D space in relation to an origin where one or more axes intersect.

Diffuse A material or surface property or channel. Diffuse shading is produced in the real world by subsurface scattering of light on an object. This process is simplified in 3D graphics but the results are very similar.

Digital Anything operated by, or created from, information or signals represented by binary digits. Examples would include the digital video stored on a DVD or the digital audio stored on a music CD. Distinct from analogue, in which information is represented by a physical variable (in an audio recording, for example, this would be via the grooves in a vinyl platter).

Displacement map A black and white image used to offset the points of an object in another image using brightness values.

Drop shadow A shadow projected onto the background behind an image or character in order to lift it off the surface.

Environment map In 3D applications, a 2D image that is projected onto the surface of a 3D object to simulate reflections of the surrounding area.

Exploded view An illustration of an object displaying its component parts separately – as though it were exploded – but arranged in such a way as to indicate their relationship within the whole object when assembled.

Export A feature provided by many applications to allow you to save a file in a format so that it can be used by another application or on a different operating system.

Extrapolate Creating new values for a parameter based on the values that have gone before.

Extrude The process of duplicating the cross-section of a 2D object, placing it in a 3D space at a distance from the original and creating a surface that joins the two together. For example, extruding a circle would create a tube.

Fall-off In a 3D environment, the degree to which light or any parameter loses intensity away from its source.

Fill In graphics applications, the content, such as colour, tone, or pattern, applied to the inside of a shape (including type characters).

Fillet A curved surface in a 3D model, which is created between two adjoining or intersecting surfaces to create a smoother, more realistic join.

Filter A component of an application that processes or converts data. In graphics applications, the term is employed to describe the features used for the application of special effects to images.

Frame An individual still image extracted from an animation sequence.

Fresnel effect In a 3D environment, the brightening of the edge of an object by increasing the intensity of reflection along the edge. As this occurs in the real world, it gives a more realistic visual effect.

Geometry What 3D objects are made out of, or rather described by. Geometry types include polygons, NURBS and Bézier patches.

Glow A material parameter used to create external glows on objects. The glow usually extends beyond the object surface by a defined amount.

Gouraud shading A means by which 3D programs 'fill in' the surface polygons of objects so that they look smooth and solid. The surfaces take on a graduated or smooth shaded look.

Greyscale The rendering of an image in a range of greys from white to black. In a digital image and on a monitor this

usually means that an image is rendered with eight bits assigned to each pixel, giving a maximum of 256 levels of grey.

Grid In some applications, a user-definable background pattern of equidistant vertical and horizontal lines to which elements such as guides, rules, type, boxes, etc., can be locked, or 'snapped'. This helps the user place elements with greater accuracy.

Height map An image used to displace or deform geometry. (*See also Displacement.*)

Hidden surface removal A rendering method, usually wireframe, that prevents surfaces that cannot be seen from the given view from being drawn.

Hue The pure spectral colour that distinguishes a colour from others. Red is a different hue from blue; and although light red and dark red contain varying amounts of white or black, they both have the same basic hue.

Interpolation A computer calculation used to estimate unknown values that fall between known ones. One use of this process is to redefine pixels in bitmapped images after they have been modified in some way – for instance, when an image is resized (called 'resampling') or rotated, or if colour corrections have been made. In such cases the program makes estimates from the known values of other pixels lying in the same or similar ranges.

Lathe In 3D applications, the technique of creating a 3D object by rotating a 2D profile around an axis – just like carving a piece of wood on a real lathe.

Layer The grouping of objects into separate partitions so that they can easily be isolated and treated separately, hidden or worked with en masse.

Map Any image applied to a texture channel for 3D rendering.

Mask A selected portion of an image, blocked out by the user to protect it from alteration during all or part of the image-editing process.

Material The combination of all the surface attributes that define the overall look of a 3D object.

Multi-pass rendering The process whereby a single scene is rendered in multiple passes, each pass producing an image (or movie or image sequence) containing a specific portion of the scene but not all of it (for example, one part of a multi-pass render may contain just the reflections in the scene, or just the specular highlights. It may also contain single objects or effects).

NURBS Non-Uniform Rational B-Spline. A special curve in 3D programs, which is defined by a mathematical equation. Splines can be linked together to form smooth, flowing surfaces with more natural looking curves. A NURB object uses less data than a

conventional polygon object to create this sort of complex and often more organic looking model.

Perspective A technique of rendering 3D objects on a 2D plane, duplicating the 'real world' view by giving an impression of the object's relative position and size when viewed from a particular point.

Phong shading A superior method of shading surfaces, giving smooth and accurate looking results.

Pixel Acronym of picture element. The smallest component of a digitally generated image, such as a single dot of light on a computer monitor. In its simplest form, one pixel corresponds to a single bit: 0 = off, or white, and 1 = on, or black. In a full-colour screen image, each pixel corresponds to 24 bits: eight for each RGB colour channel.

Plug-in Software, usually developed by a third party, which extends the capabilities of a particular program. Plug-ins are commonly used in image-editing and page-layout applications for such things as special effect filters.

Polygon Composed of points joined by edges, polygons are the basic building blocks of 3D objects. They are not the only things that 3D objects can be constructed from, but when they are rendered, polygons are used 99 per cent of the time.

Primitive The basic geometric element, such as a cube or cylinder, from which more complex objects can be built.

Rasterize The conversion of a vector graphics image into a bitmap. The process may introduce aliasing, but it's a necessary evil when preparing vector-based images for general use.

Raytracing A rendering algorithm that simulates the physical and optical properties of light rays as they reflect off a 3D model, producing realistic shadows and reflections.

Real-time The actual time in which things happen on your computer. As a computing term, real-time refers to operations that are being performed as the user watches in response to pre-programmed triggers or user-interaction. This covers everything from a character appearing on screen after a key has been pressed, to the hero in a computer game jumping from one platform to another. You're not watching a pre-created animation, but the results of calculations that are happening right now.

Reflection The image of an environment or surrounding objects in the surface of a reflective object.

Refraction The effect when light is bent, typically through passing from one medium to another, such as air to water.

Rendering The process of creating a 2D image from 3D geometry to which lighting effects and surface textures have been applied.

RGB Red, green, blue. The primary colours of the 'additive' colour model – used in video technology (including computer monitors) and for graphics (for the Web and multi-media, for example) that will not ultimately be printed by the four-colour (CMYK) process method.

Scale A common transformation that shrinks or enlarges an object or image horizontally, vertically, or in a 3D program, on the Z axis.

Shading The process of filling in the polygons of a 3D model with respect to viewing angle and lighting conditions.

Skin In 3D applications, a surface stretched over a series of 'ribs', in the manner of an aircraft wing or the hull of a boat.

Specular map A special texture map used in 3D applications to control highlights. These are usually greyscale maps, with the white areas in the map more responsive to lighting than black areas.

Spline The digital representation of a curved line, as defined by three or more control points.

Surface geometry In 3D applications, the geometry that underlies a surface, becoming visible when the surface is simplified and any textures removed.

Sweep The process of creating a 3D object by moving a profile along a curved path.

Texture The surface definition of an object.

Triangle The simplest type of polygon, made from three connected vertices. The triangle is the basic polygon used in most 3D rendering processes.

Vector A mathematical description of a line that is defined in terms of physical dimensions and direction. Vectors are used in drawing packages to define shapes (vector graphics) that can be repositioned or resized at will.

Vertex A technical term used for the points that, when connected, make up the mesh of a 3D model.

View A window in a 3D program depicting the 3D scene from a given vantage point.

Wireframe A skeletal view, or a computer-generated 3D object before the surface rendering has been applied.

Z-Buffer A 3D renderer that solves the problem of rendering two pixels in the same place (one in front of the other) by calculating and storing the distance of each pixel from the camera (the 'z-distance'), then rendering the nearest pixel last.

INDEX

FURTHER INFORMATION

Magazines:
Computer Arts
3D World
Digit
MacUser

General 3D and Graphics websites:
www.turbosquid.com
www.3Dcafe.com
www.3Dbuzz.com
www.3Dlinks.com
www.3Dark.com
www.3Dluvr.com
www.3dgate.com
www.phong.com
www.gcchannel.com
www.grafx-design.com
www.3dsource.net
www.sketchovision.com
www.itgoesboing.com
www.3d-io.com

Software Information and Support:
www.maxon.net
www.newtek.com
www.aliaswavefront.com
www.corel.com
www.caligari.com
www.adobe.com
www.discreet.com
www.amorphium.com
www.electricimage.com

Picture Acknowledgements:
AMBLIN/UNIVERSAL PICTURES:
page 105B, *Jurassic Park* © Universal
Pictures/Amblin Entertainment.

CORBIS:
page 6T Carl and Ann Purcell, page 6B
Edimedia, page 7 Pizzoli Alberto/Sygma,
page 8 David Lees, page 9 Bettmann,
page 12 © National Gallery Collection;
By kind permission of the Trustees of
the National Gallery,London, page 13
Francis G.Meyer

KOBAL COLLECTION:
page 105T, *Tron* © Walt Disney, Disney
Enterprises, Inc.

M.C.ESCHER:
page 11 Concave and Convex by
M.C.Escher © 2003 Cordon Art-Baarn-
Holland. All rights reserved.